THE ART OF

Disney · PIXAR

INSIDE OUT

FOREWORD BY
AMY POEHLER
INTRODUCTION BY
PETE DOCTER

RALPH EGGLESTON Digital painting

Library of Congress Cataloging-in-Publication Data is available.

ISBN: 978-1-4521-3518-2

Tony Fucile, Pencil [back flap]
Chris Sasaki, Pencil and Marker [back cover, top left]
Ronnie Del Carmen, Marker, Watercolor, and White Out
 [back cover, top right to front cover, top left]
Dan Holland, Marker and Watercolor [back cover, bottom left]
Albert Lozano, Collage, Ink, and Charcoal [back cover,
 bottom center]
Tony Fucile, Pen [back cover, bottom right]
Ronnie Del Carmen, Pencil and Watercolor [front cover, top
 center]
Ronnie Del Carmen, Pen, Pencil, and White Out [front cover,
 bottom left]
Albert Lozano, Marker and China Marker [front cover, center]
Dan Holland, Ink and Watercolor [front cover, bottom right]
Pete Docter, Pen [front flap]
Ralph Eggleston, Digital [case illustration]
Endpapers: Bert Berry, Digital [endpapers]

Manufactured in China

Designed by Jessi Rymill
Jacket photograph by Deborah Coleman and Neil Egan

10 9 8 7 6 5 4 3 2 1

Chronicle Books LLC
680 Second Street
San Francisco, California 94107
www.chroniclebooks.com

THE ART OF

Disney · PIXAR

INSIDE OUT

FOREWORD BY
AMY POEHLER

INTRODUCTION BY
PETE DOCTER

CHRONICLE BOOKS
SAN FRANCISCO

RONNIE DEL CARMEN Pencil

FOREWORD

Amy Poehler

Inside Out explores the last frontier: The Human Mind. It is the story of a 12-year-old girl named Riley, and the emotions that live inside her head—Joy, Sadness, Anger, Fear, and Disgust. It asks big questions: What if your emotions had feelings too? What if they lined up each day, like a new version of the Seven Dwarfs, and set out to finish the task at hand? How can the head of a young girl be home to so much adventure? Who is in charge when everything starts to change? Is it OK to not be OK all of the time?

Inside Out is also hilarious. And beautiful. Like life.

When director Pete Docter and producer Jonas Rivera asked me to be the voice of Joy, it was a huge and generous gift. Working on a Pixar film is like standing close to a glistening, beautiful machine. Every part of the machine is unique and in constant motion, operated by incredibly talented people who work hard to serve the story. I was able to spend hours Living in Joy, which meant I could speak from the heart and love with abandon. It was emotional cardio and I am deeply convinced that playing Joy has added extra years to my life. Some days were spent laughing, while others were spent crying.

As Joy fights against change, we get to see the struggle between her and Sadness, soulfully voiced by Phyllis Smith. Their journey together teaches us about compromise and negotiation, and reminds us that no one can achieve anything alone. Joy and Sadness make their way through different parts of the Mind in an attempt to get back to Headquarters. Along their journey they visit colorful and bizarre environments. Long Term Memory. Abstract Thought. Dream Productions. Imagination Land. While Joy and Sadness struggle, the ragtag group of Fear, Anger, and Disgust are inside Headquarters running the show. The hilarious Bill Hader, Lewis Black, and Mindy Kaling all remind us how funny and frustrating each emotion can be.

Life isn't as simple as being "happy" or "sad," and when our emotions rub shoulders, we see where true pain and beauty live. Nobody understands this more than the folks at Pixar.

Writer and director Pete Docter says watching his daughter Elie grow and change is what inspired the film. We first met Elie when she was the young and brave voice of "Young Ellie" in the amazing film, *Up*. Now Elie Docter is a young woman (because as much as scientists have tried, they still haven't found a way to stop children from growing older). *Inside Out* is about the things that happen when our young and brave voices start to change. It is a buddy comedy, a road movie, a Christmas film, a classic Western, a sci-fi thriller, a Bollywood musical, and a comic book blockbuster. Ok, maybe I am genre pandering, but it is for sure a deep and funny look at what happens when our emotions jostle for control.

Please enjoy this book filled with the beautiful art that inspired the film. I am amazed by the scope and depth of the artist's work that is contained here. I can't draw a bath. If the world was left up to me we would all be living in tents on a dirt road and using rocks for money. I continue to be in awe of what these artists do and I am forever grateful that I was asked to give a voice to Joy. At the end of the film, Joy and Sadness hold hands and a new color is formed. That is what *Inside Out* and the films of Pixar do. They invent new colors. They create new emotions. They introduce us to new worlds. And the best part is that these places feel like home, because they have been with us all along.

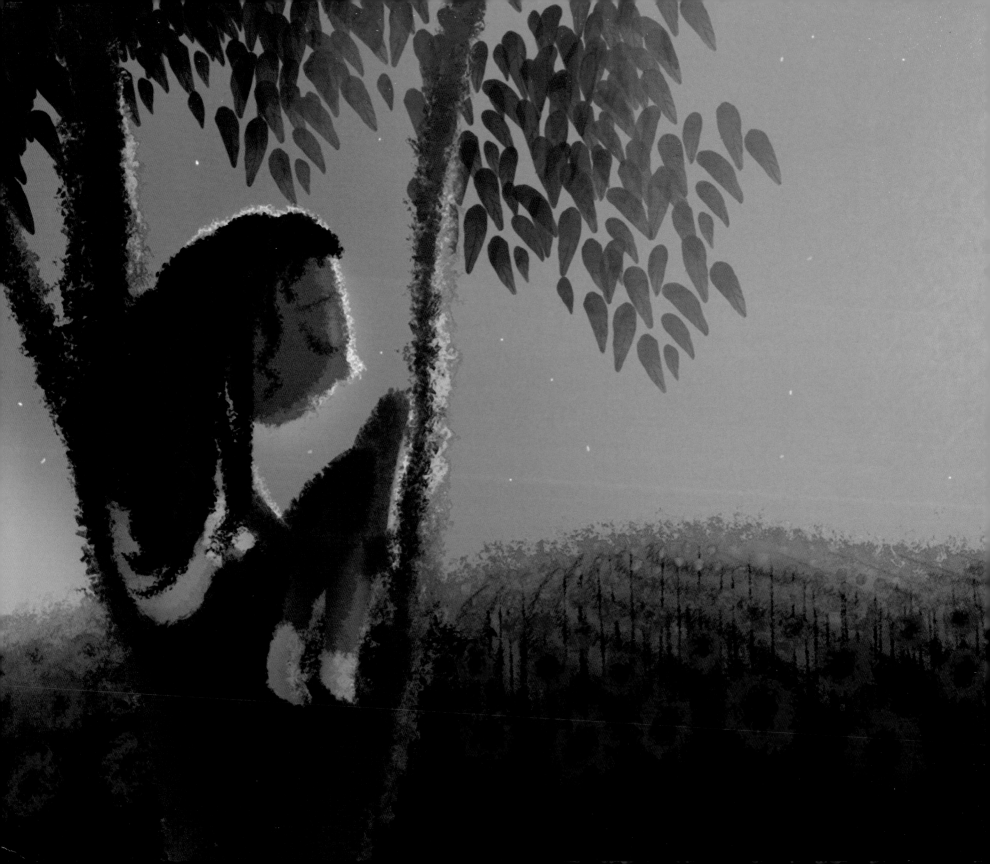

INTRODUCTION

Pete Docter

When I first pitched this idea to people—"It's a movie about the emotions inside a kid's mind!"—I seemed to get one of two reactions. They would either give me a wide-eyed smile, or stare at me blankly and tilt their head like Lil' Nipper the RCA dog. Eventually I came to realize that both of these responses were actually the same. People were saying, "Yeah, good luck making that."

The idea was rather abstract, but in my enthusiasm I didn't realize just how difficult it would be to make it concrete. Most our films had somewhere to start: bugs, fish, robots . . . even our monsters were based on some combination of animals. But what do emotions look like? Or abstract thought? Or the subconscious? Here we had nothing to measure against, nothing concrete to tell us when we'd got it right.

Of course, the answer to what the mind looks like came from the mind—specifically, the minds of our amazing artists. The designs emerged slowly, vaporous at first, gaining form and solidity. Some would lock in quickly, while others were more difficult to capture. It was a mysterious, fascinating process—and a little scary when we'd look at the rapidly shrinking schedule.

But over time, the characters and world moved from foggy notions into actual things we could build, paint, and light in the computer.

This process felt so unique and exciting that we wanted to share the experience with you. So we organized the artwork in this book much the same way it felt to us making it. First you'll see a vast array of concepts; far-out stuff from a wide array of artists. Out of hundreds of drawings and paintings we found a few that felt right, which we refined and made more specific; those are in the center of the book. Towards the end you'll see work done as the movie was being made: design refinements, animation thumbnail drawings, and lighting studies. I've included a few captions here and there to give you more information about the context of a drawing. But other than that, we decided to let the artwork speak for itself.

Looking back, I think those of us who worked on the film all relate to Joy's journey through the unknown expanses of the Mind. It feels like we all went on that same trek. We hope this book allows you to experience a little of what it was like to make it.

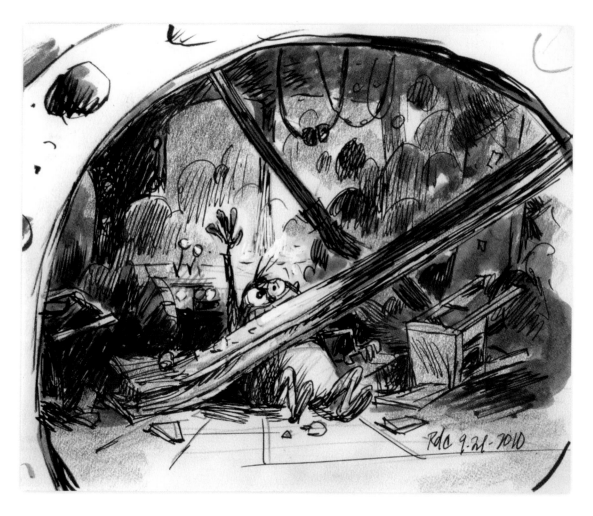

RONNIE DEL CARMEN Marker and pen

In an early version of the story, an upheaval in Riley's life caused a literal earthquake inside Headquarters.

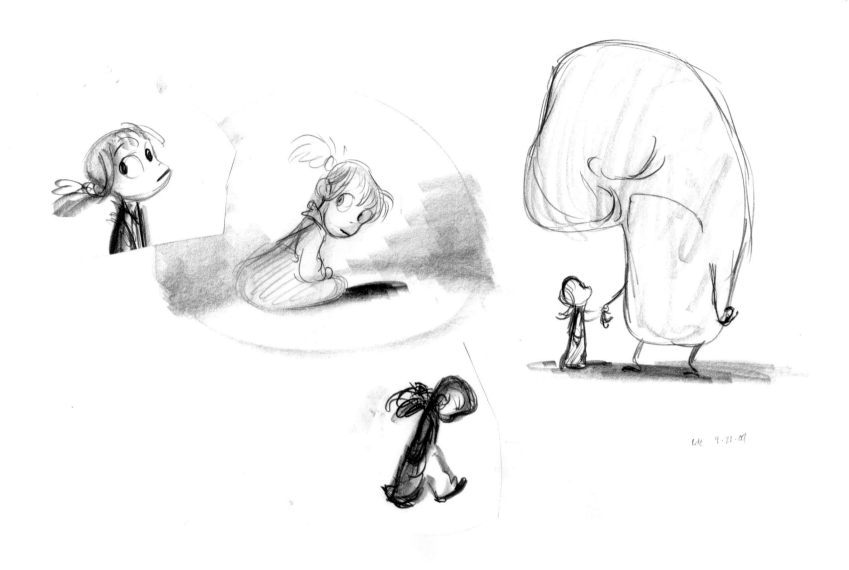

RONNIE DEL CARMEN Pencil

Early story outlines had Riley transported inside her
own mind. Here she comforts Sadness.

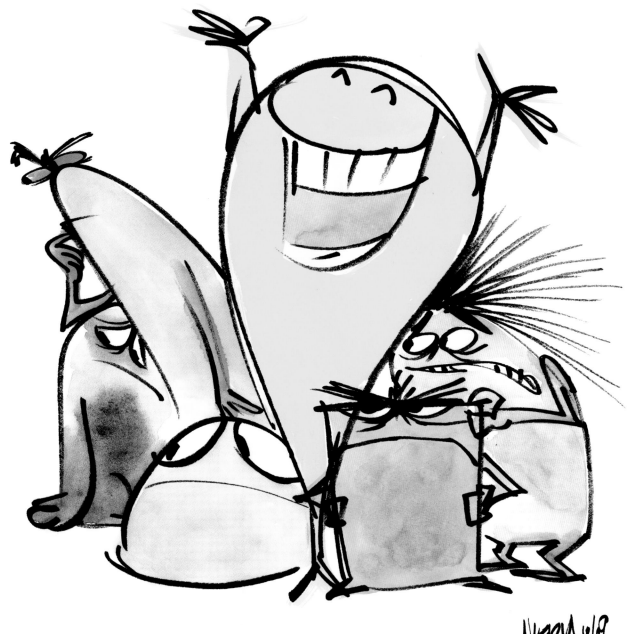

RALPH EGGLESTON Digital painting

Joy and Riley live in two different worlds, which made it
difficult to show their emotional connection on screen.
To solve this we tried giving Joy the ability to appear in
the external world.

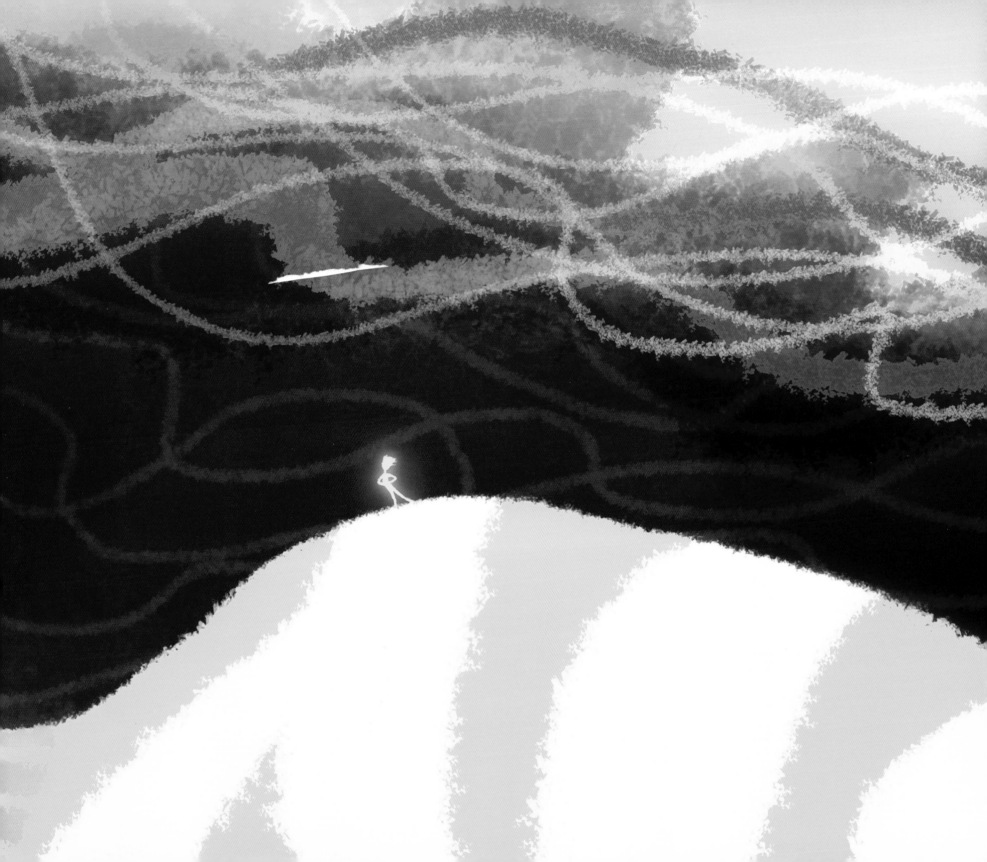

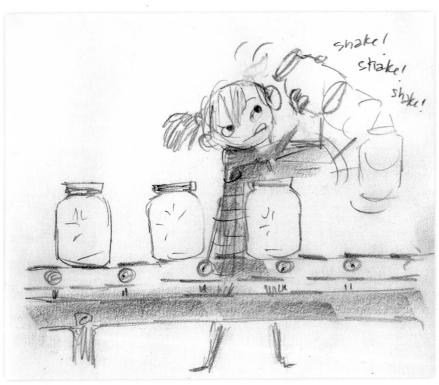

LEFT AND ABOVE
RONNIE DEL CARMEN Pencil

Jars as memory containers.

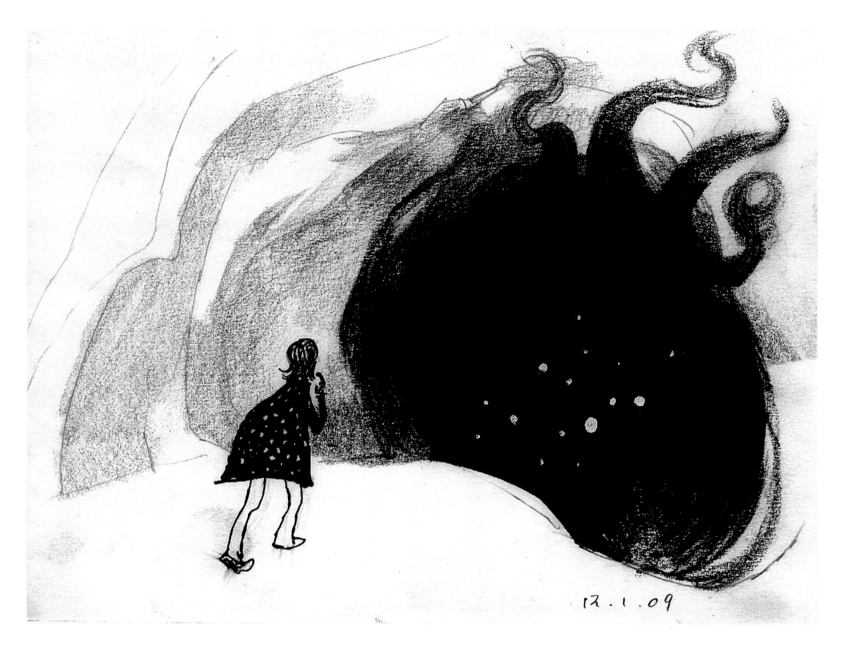

RONNIE DEL CARMEN Pencil and marker

Riley and Gloom (Depression), a dark ooze that
spread throughout the Mind.

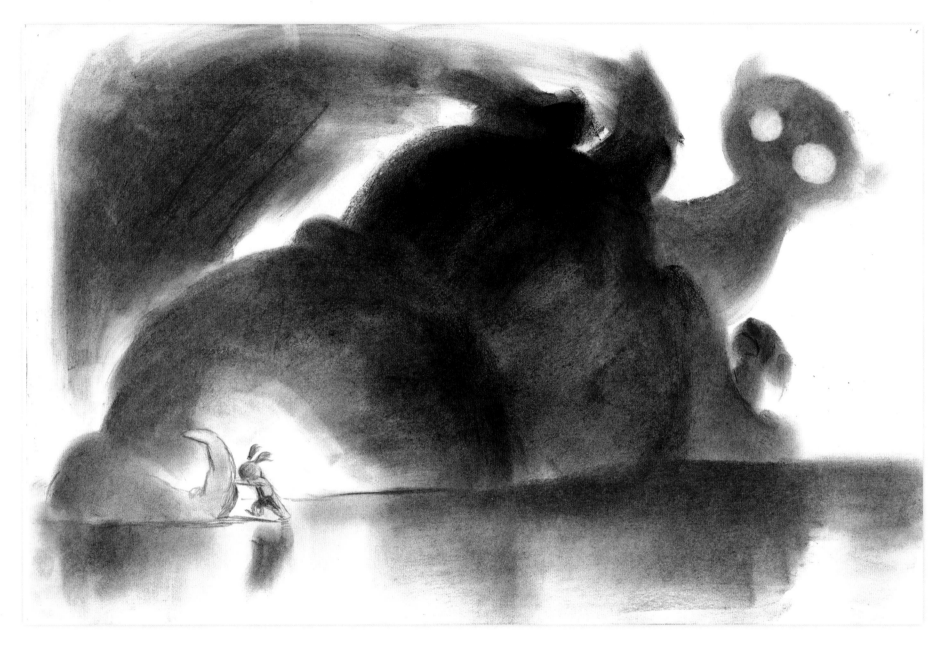

RONNIE DEL CARMEN Pastel and colored pencil

Gloom as a character.

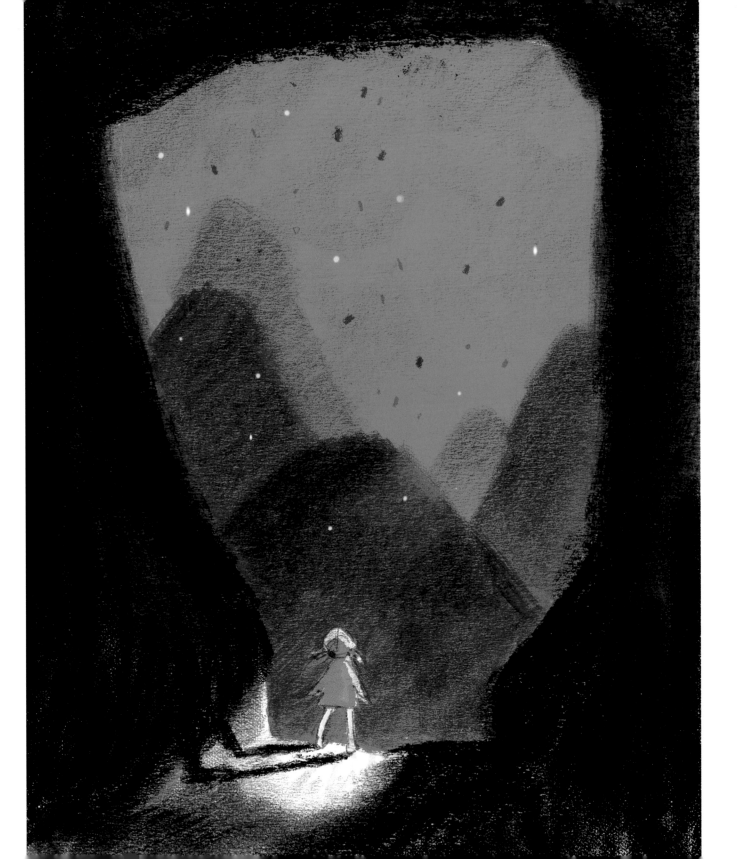

RONNIE DEL CARMEN
Digital painting and pastel

Riley in the Memory Dump.

DON SHANK Colored pencil and ink

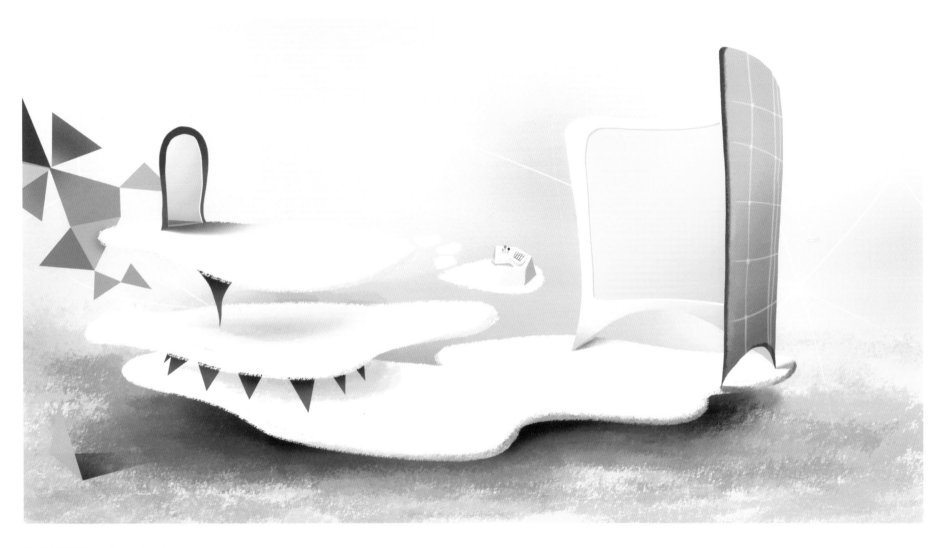

DON SHANK Digital painting

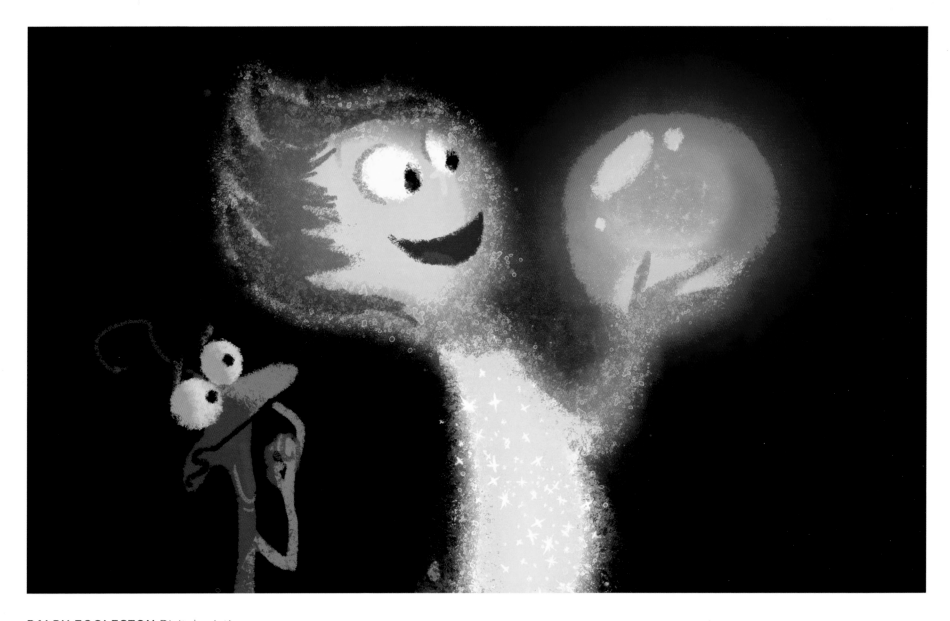

RALPH EGGLESTON Digital painting

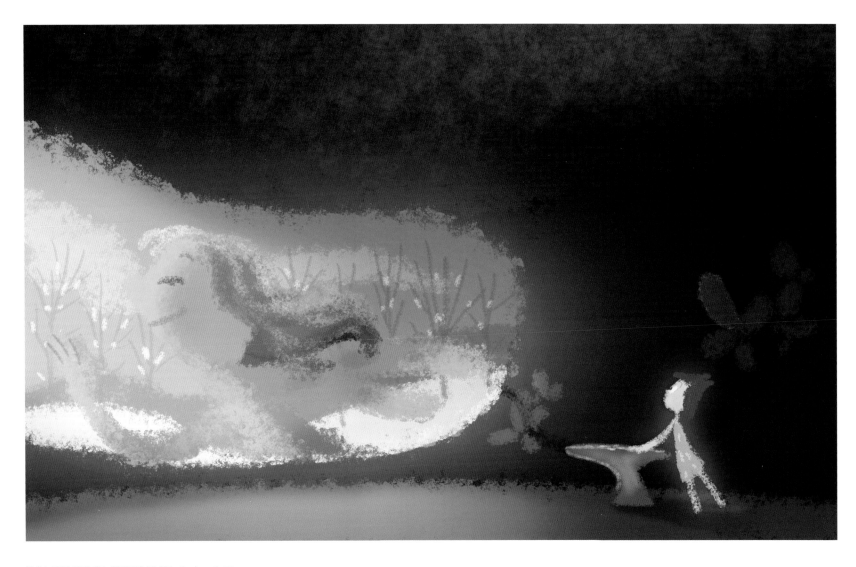

RALPH EGGLESTON Digital painting

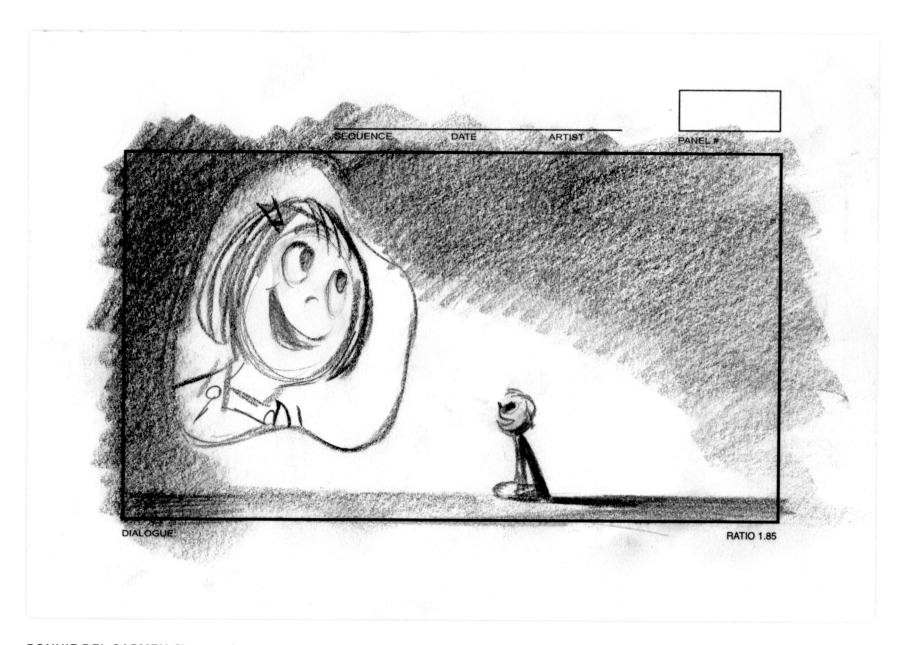

SEQUENCE DATE ARTIST PANEL #

DIALOGUE RATIO 1.85

RONNIE DEL CARMEN China marker

DATE ARTIST PANEL #

DIALOGUE: RATIO 1.85

RONNIE DEL CARMEN Marker and china marker

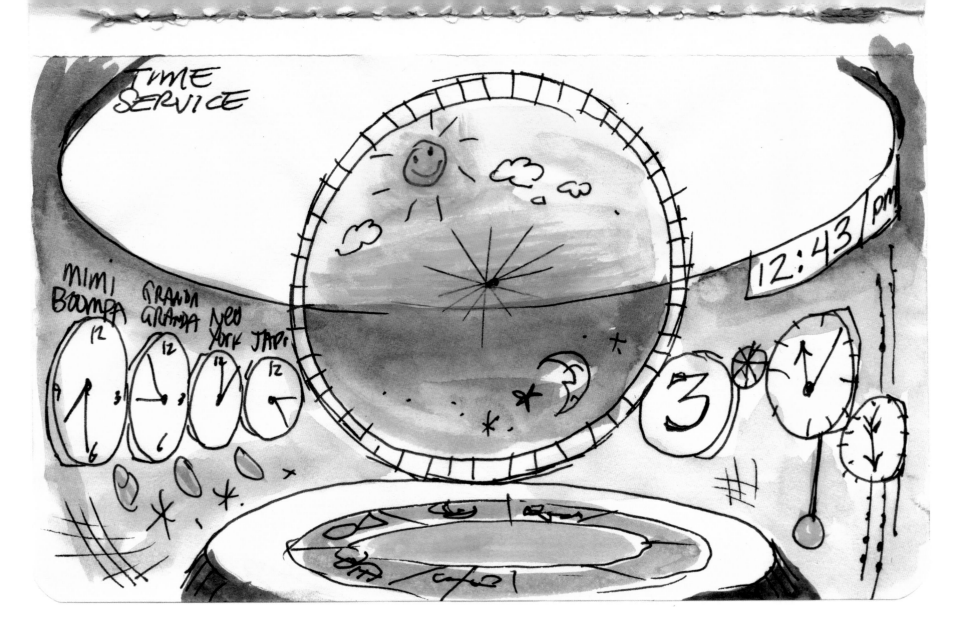

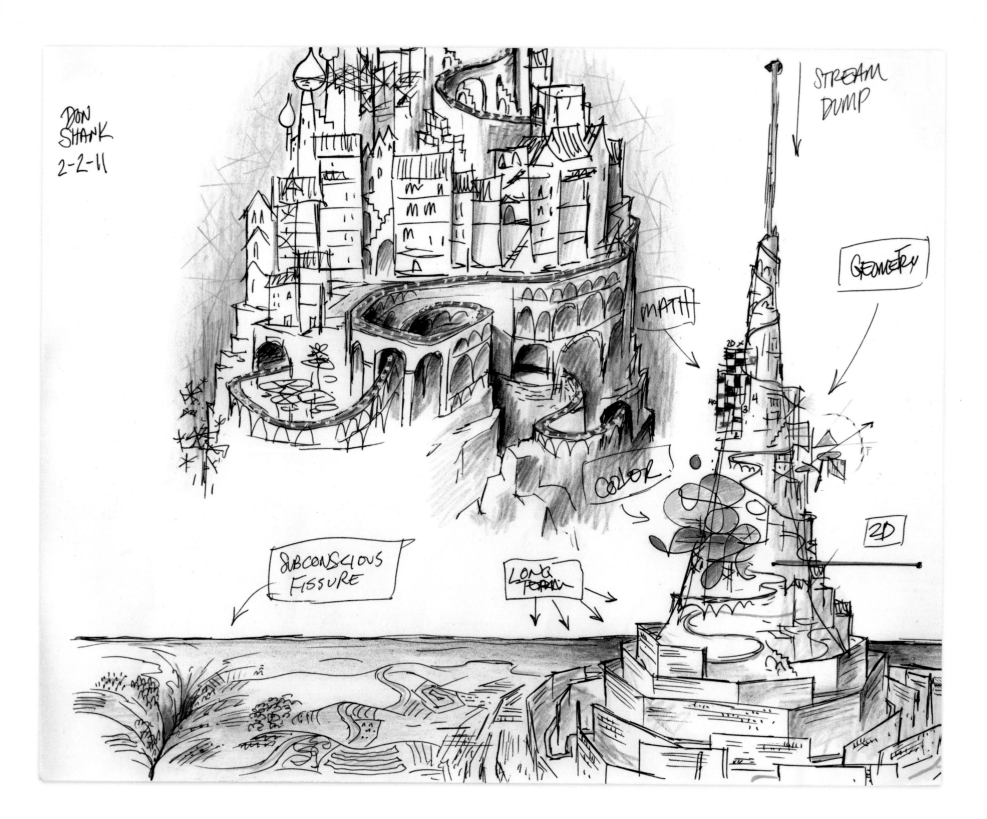

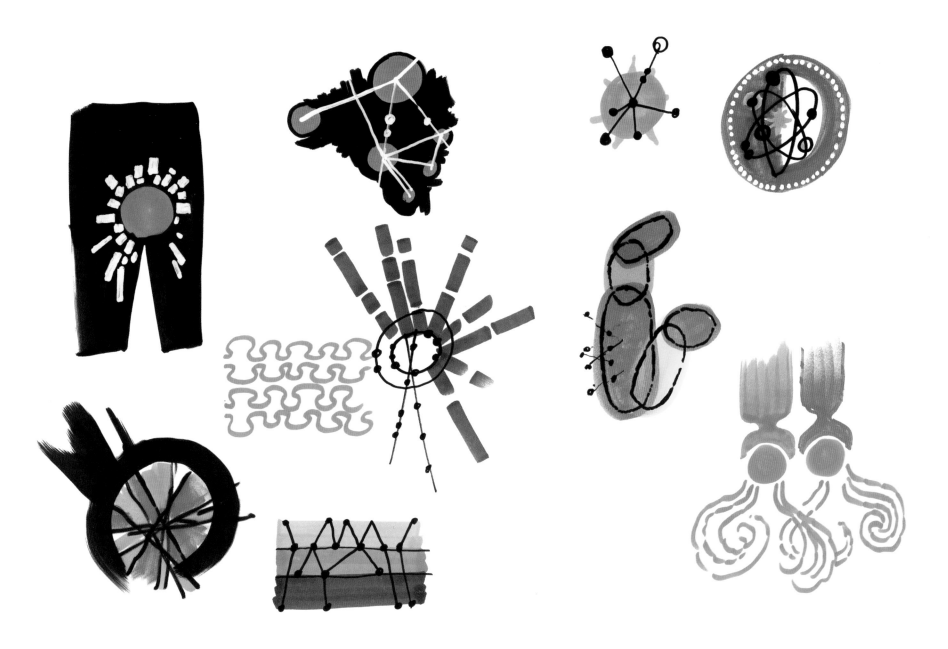

ABOVE
DAN HOLLAND Marker

Shapes and patterns to use in designing the Mind.

OPPOSITE
DON SHANK Colored pencil and ink

31

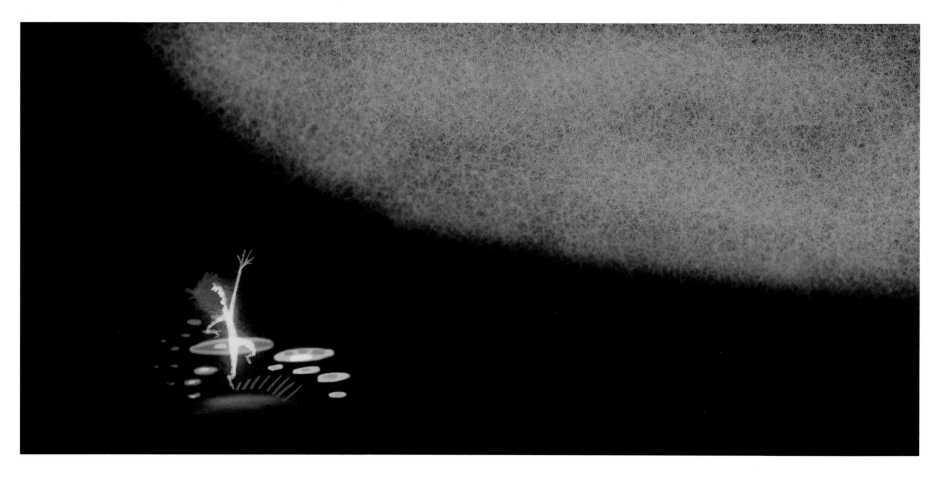

RALPH EGGLESTON Digital painting

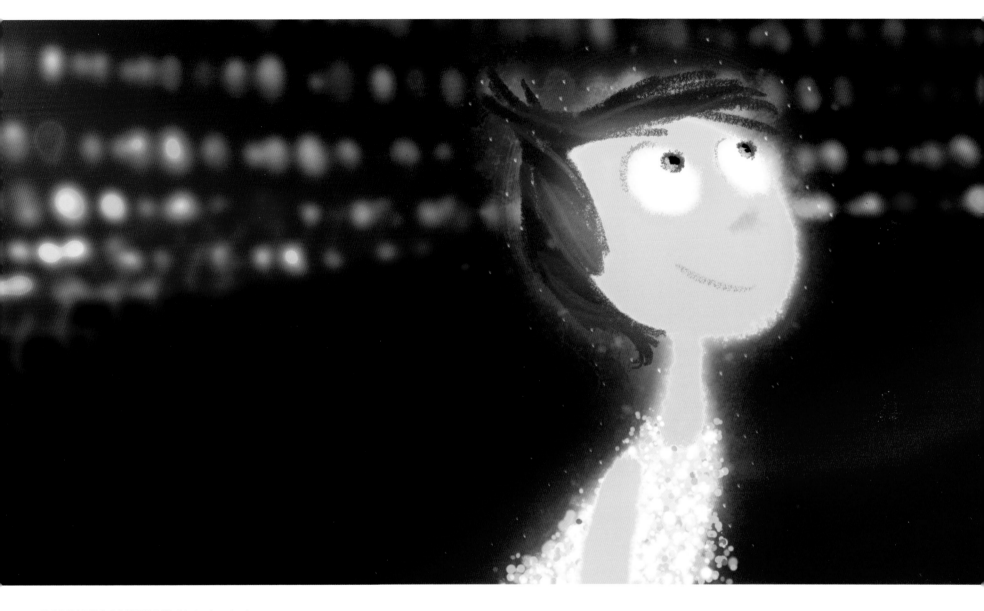

RALPH EGGLESTON Digital painting

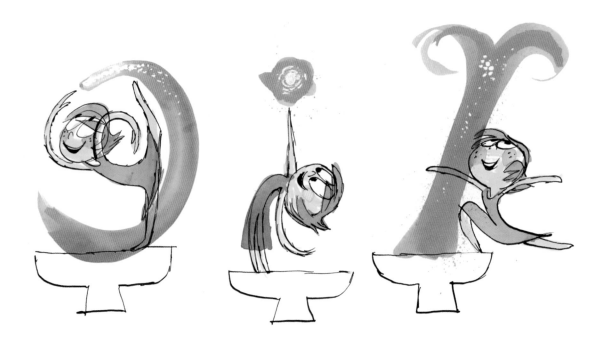

DAN HOLLAND Watercolor and ink

An early concept for a control panel where emotions
could "paint" feelings with light-energy.

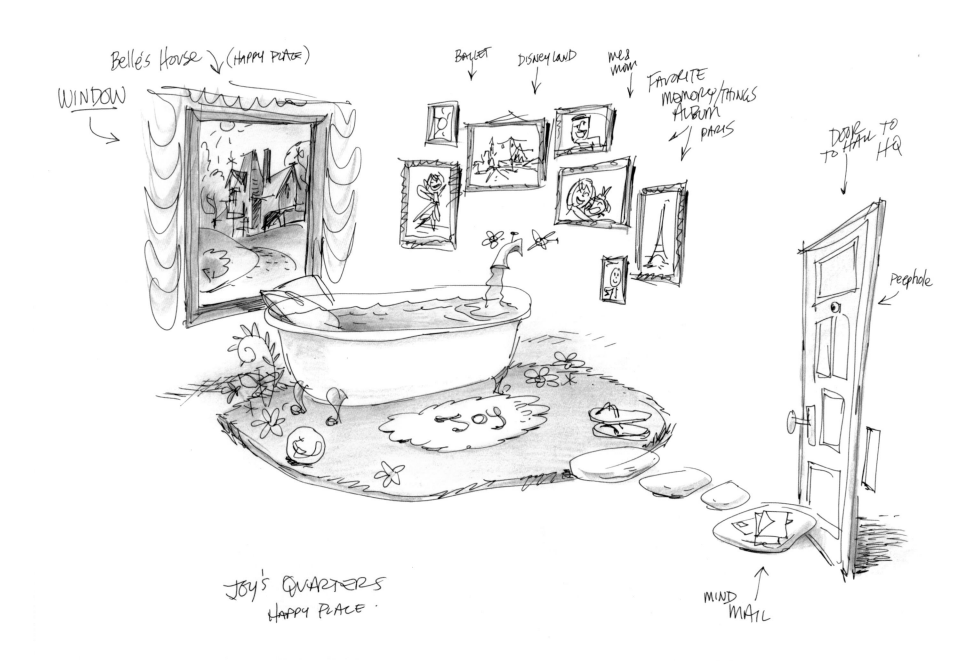

Belle's House ↓ (HAPPY PLACE)

WINDOW

BALLET DISNEY LAND ME & MOM FAVORITE MEMORY/THINGS ALBUM

↓ PARIS

DOOR TO HALL TO HQ

Peephole

JOY

JOY'S QUARTERS
HAPPY PLACE.

MIND MAIL

DON SHANK Colored pencil and ink

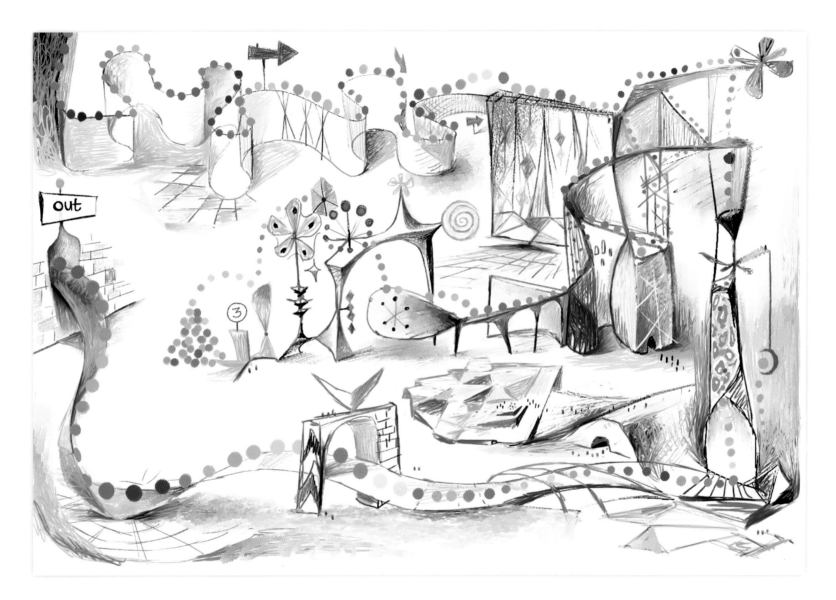

ABOVE
DON SHANK Colored pencil

Perhaps memories travel through the Mind on one
long continuous conveyor belt.

OPPOSITE
RALPH EGGLESTON Digital painting

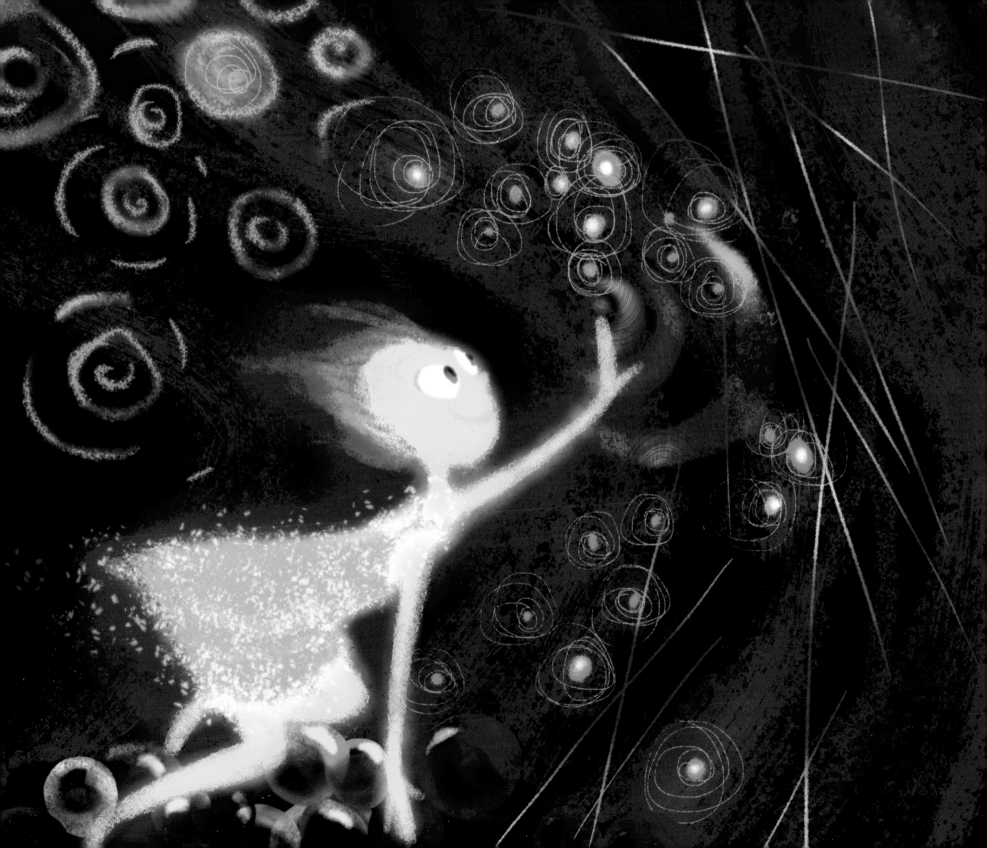

THIS PAGE
RALPH EGGLESTON Pastel

OPPOSITE
ALBERT LOZANO Marker

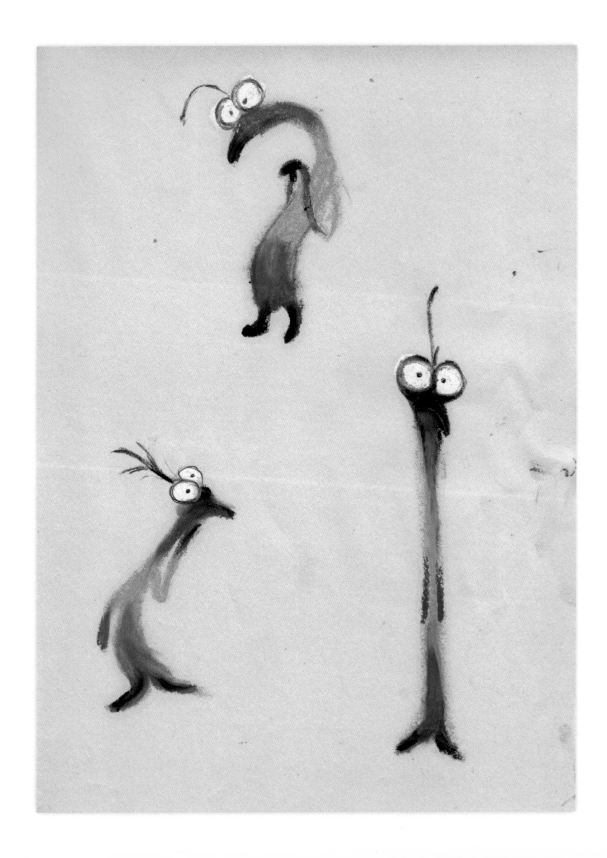

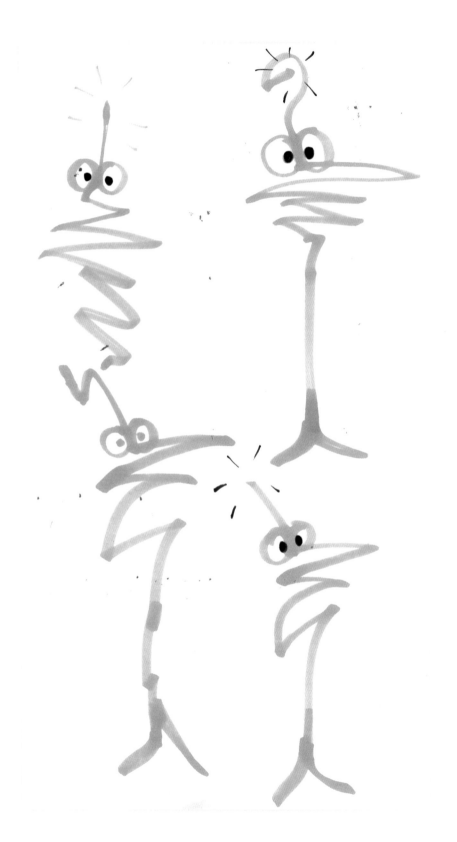

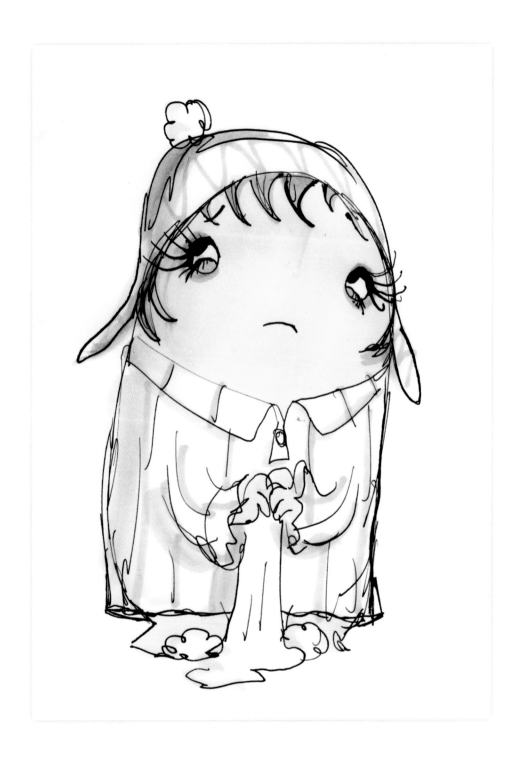

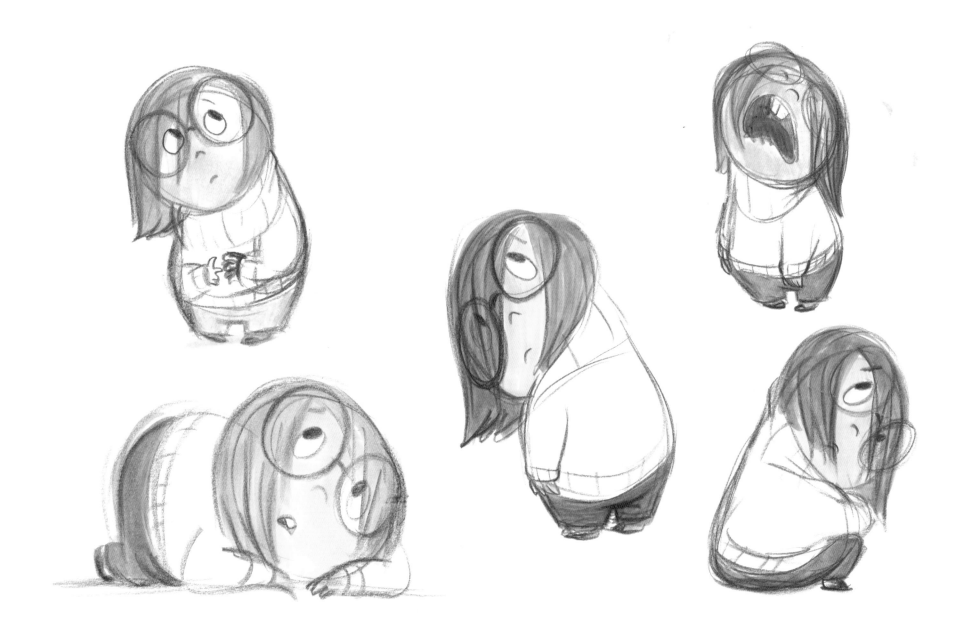

ABOVE
ALBERT LOZANO Marker and china marker

OPPOSITE
ALBERT LOZANO Marker and ink

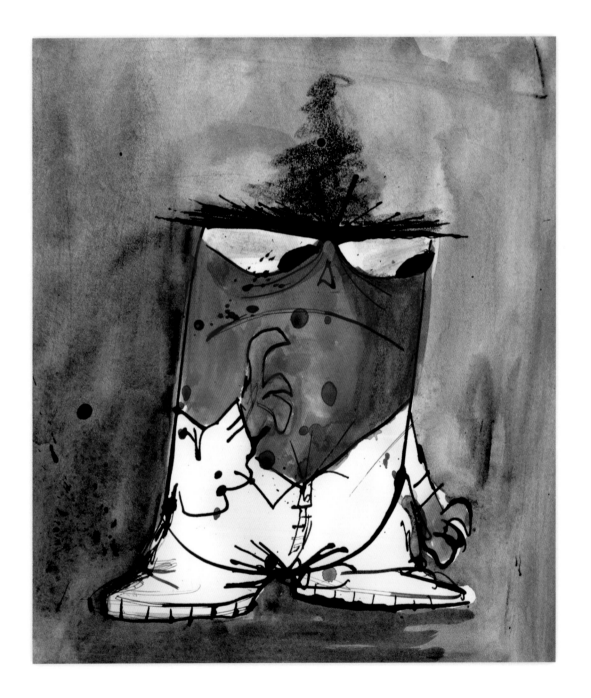

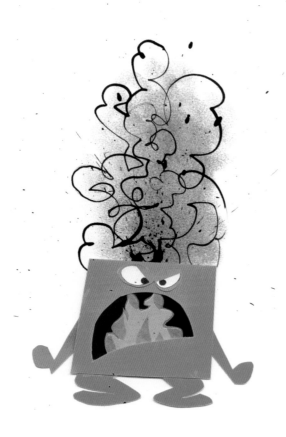

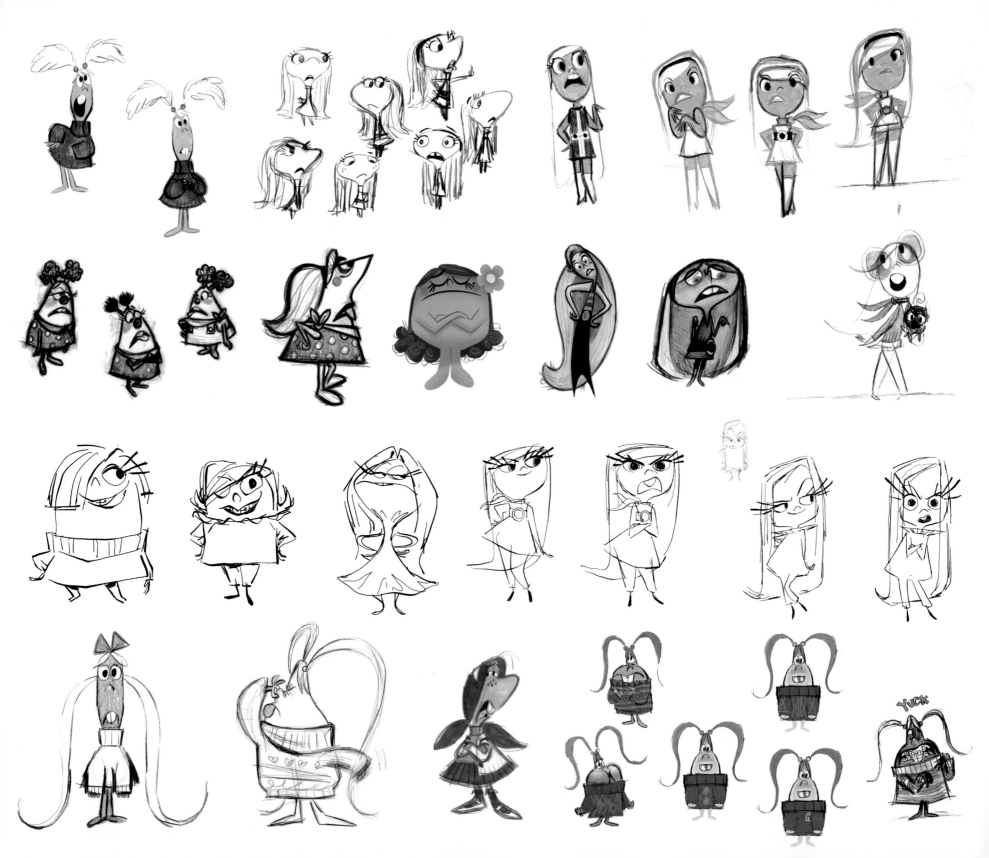

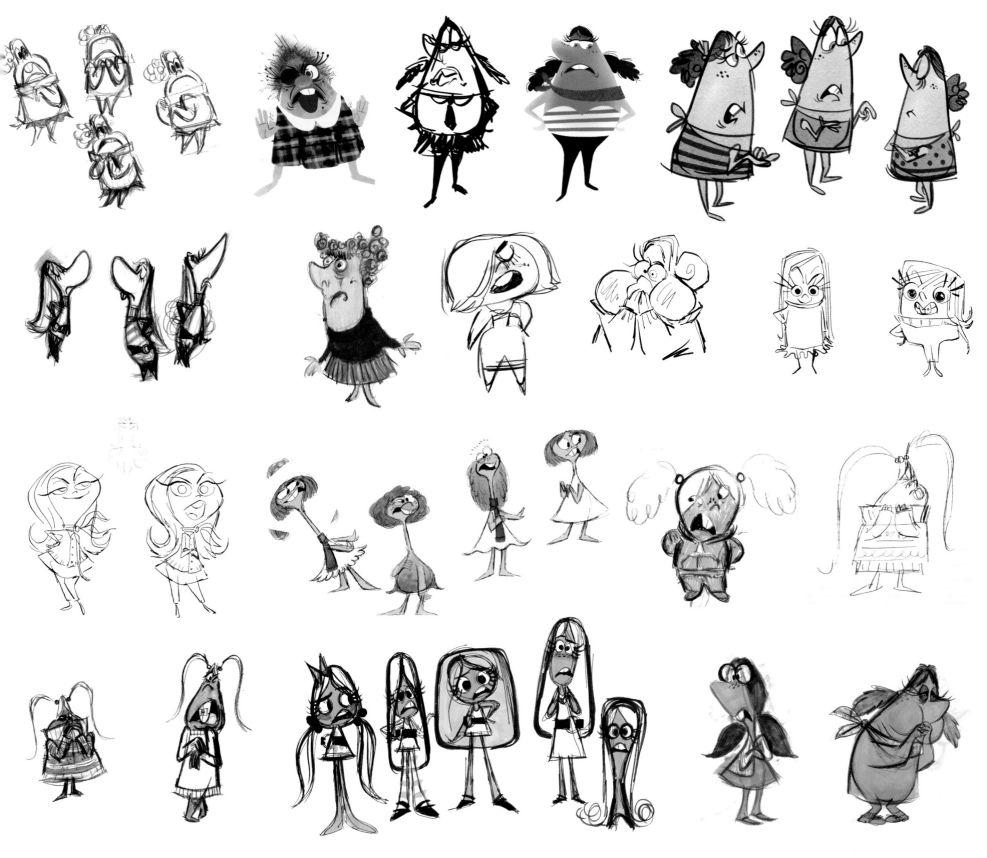

DANIEL ARRIAGA
BERT BERRY
RALPH EGGLESTON
TONY FUCILE
TOM GATELY
ALBERT LOZANO
MATT NOLTE
CHRIS SASAKI

Surprisingly, Disgust was the
most difficult Emotion to design.

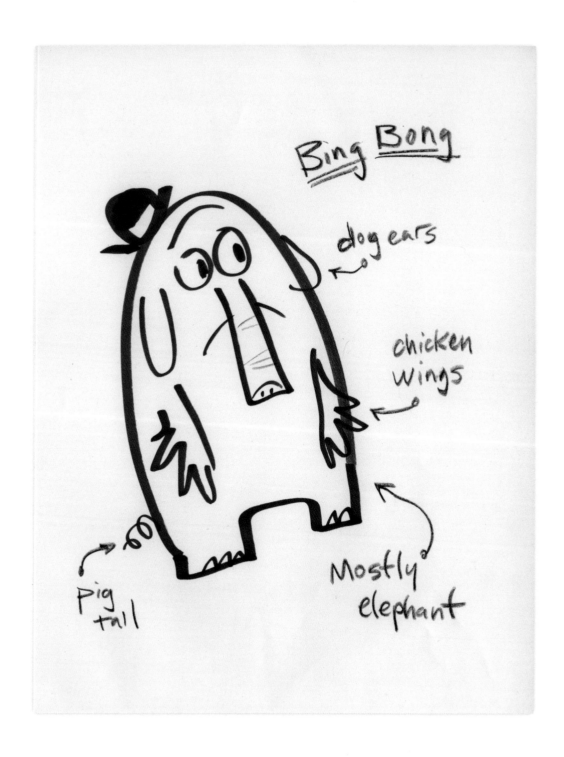

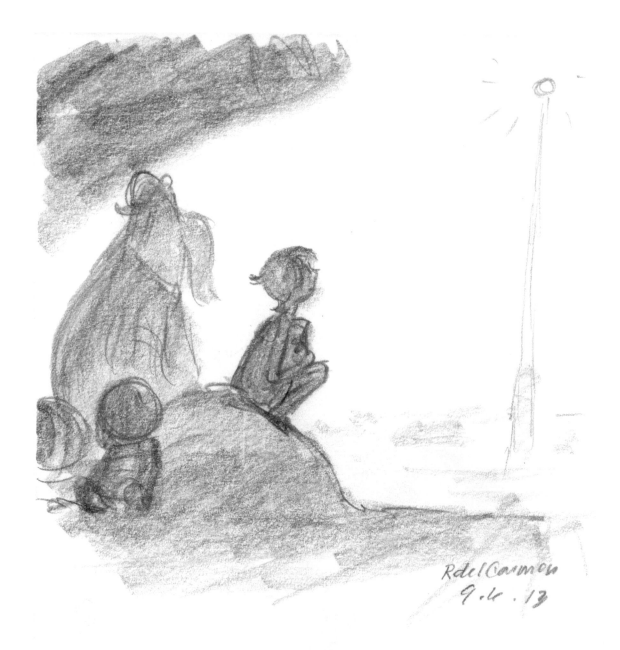

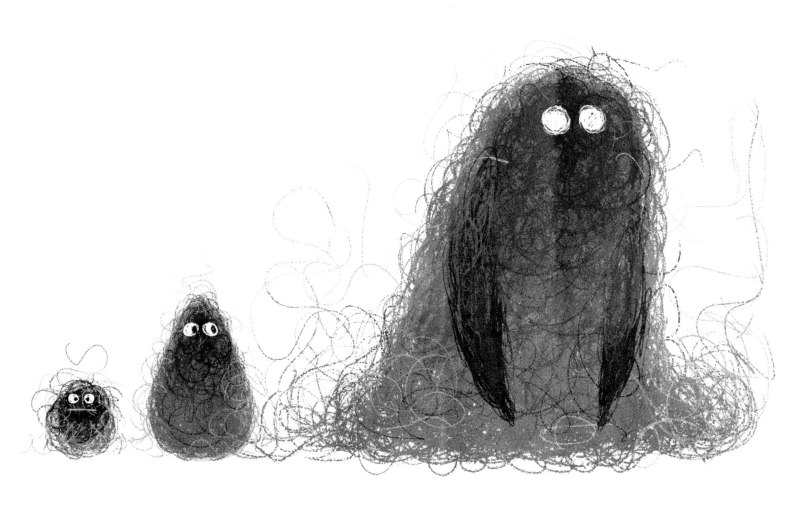

CHRIS SASAKI Digital painting

Gloom (an early antagonist) grew in size as he gained importance.

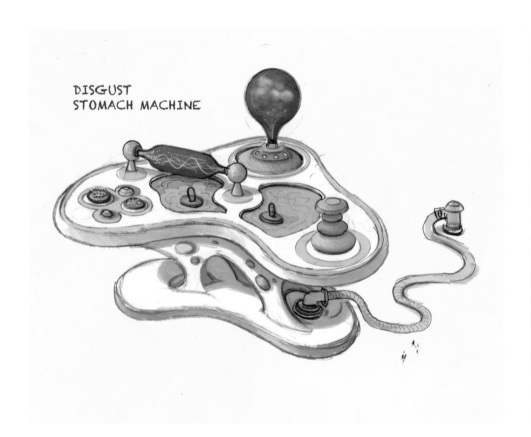

DISGUST
STOMACH MACHINE

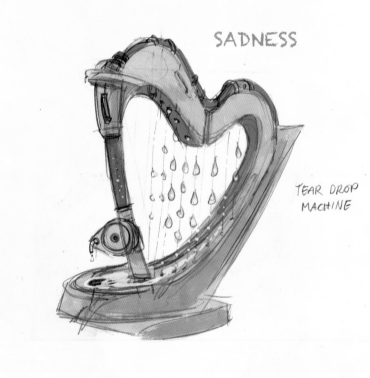

SADNESS

TEAR DROP
MACHINE

KRISTIAN NORELIUS
Pencil and digital painting

Instead of just one, maybe there are multiple
control panels, one for each Emotion?

RIGHT
RALPH EGGLESTON Digital painting

OPPOSITE
DON SHANK Digital painting

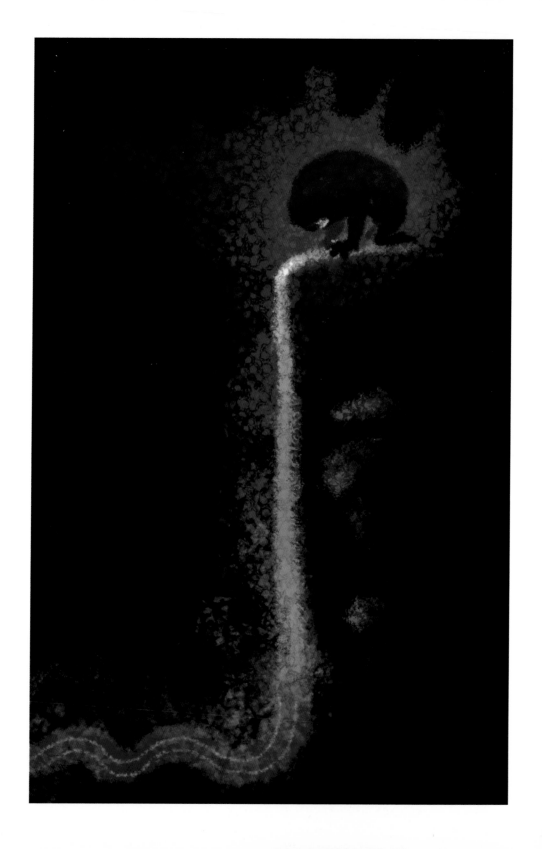

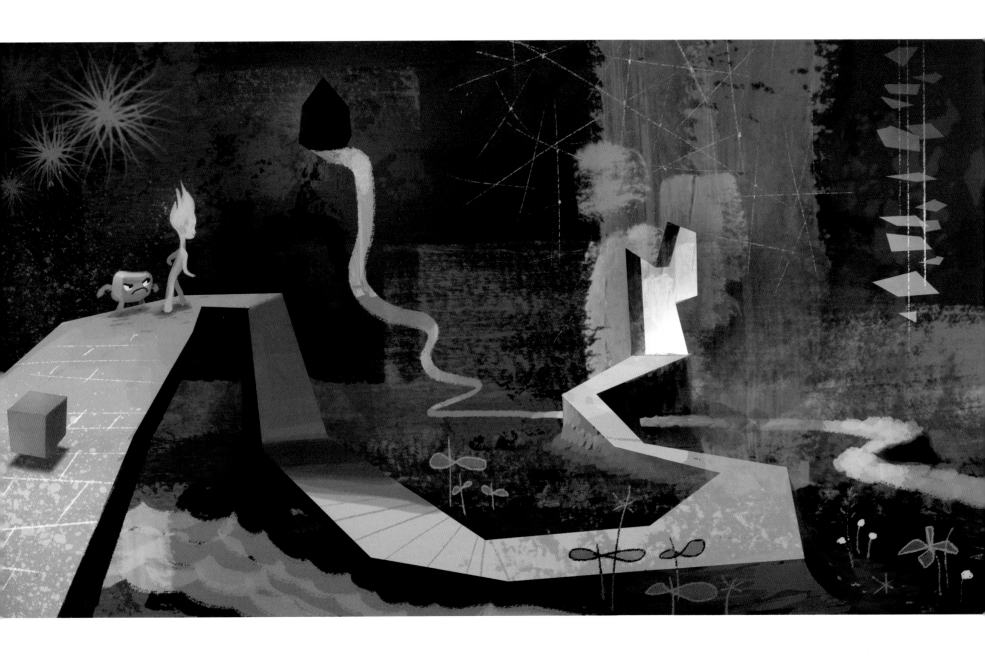

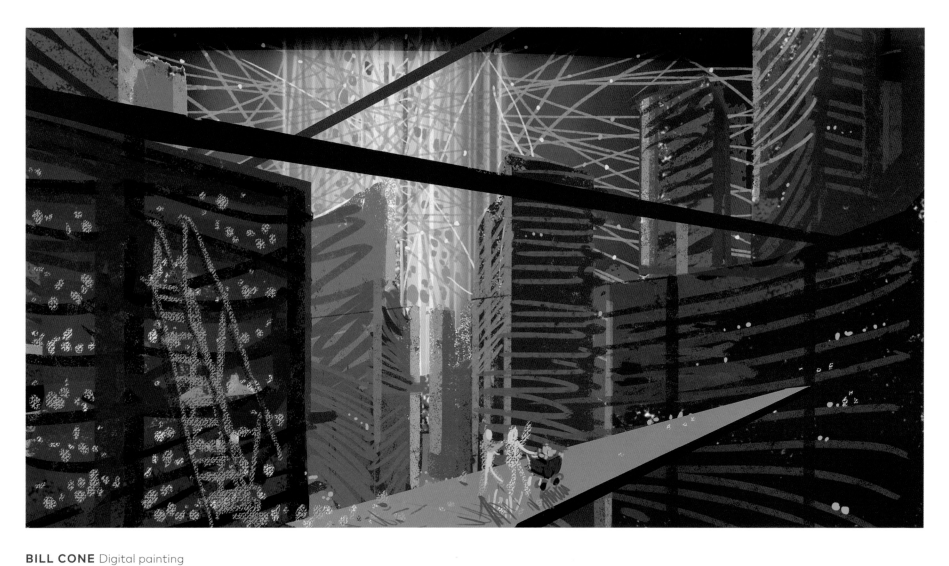

BILL CONE Digital painting

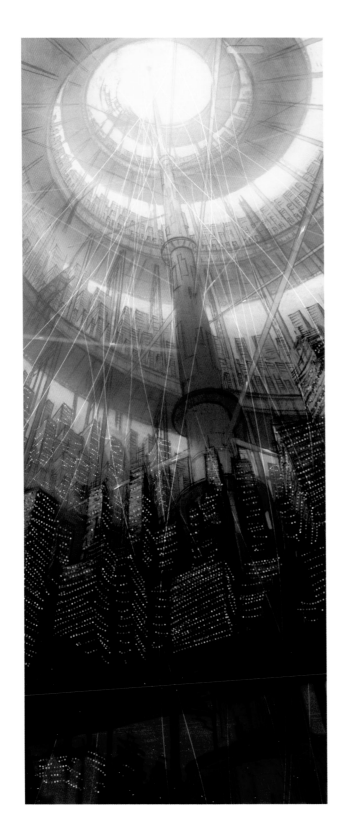

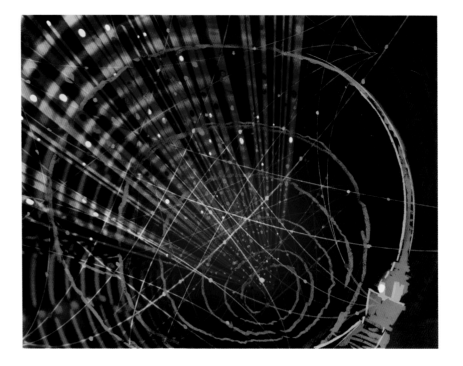

RALPH EGGLESTON and KRISTIAN NORELIUS Digital painting

Finding an overall design concept for the Mind World was probably our biggest design challenge. This changed many times throughout development and production, depending on story needs. Here, Long Term Memory was arranged in a column descending from Headquarters, with old fading memories stored at the bottom.

BILL CONE Digital painting

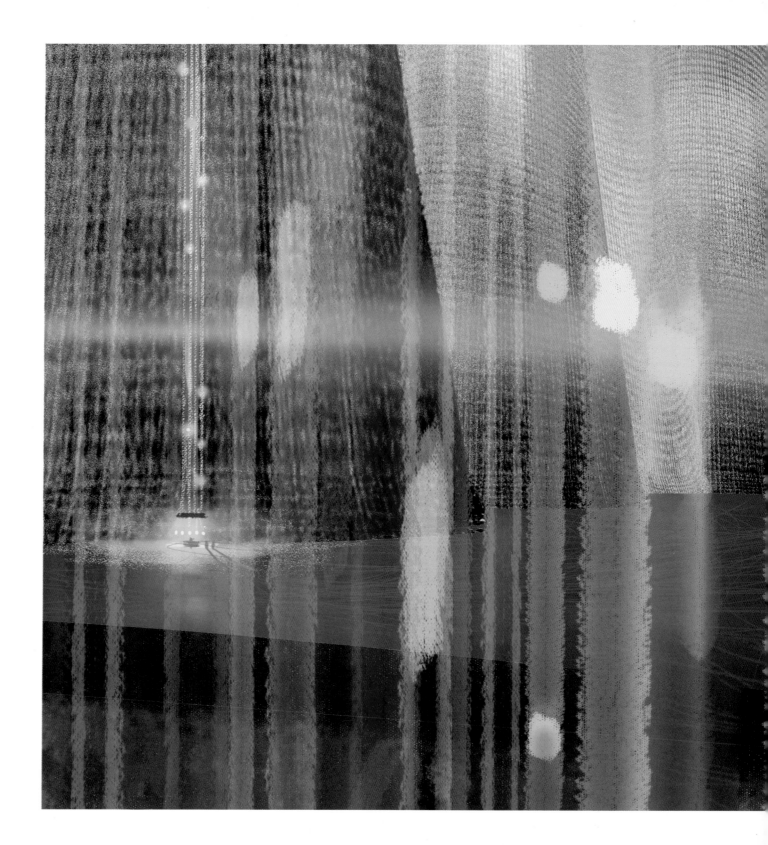

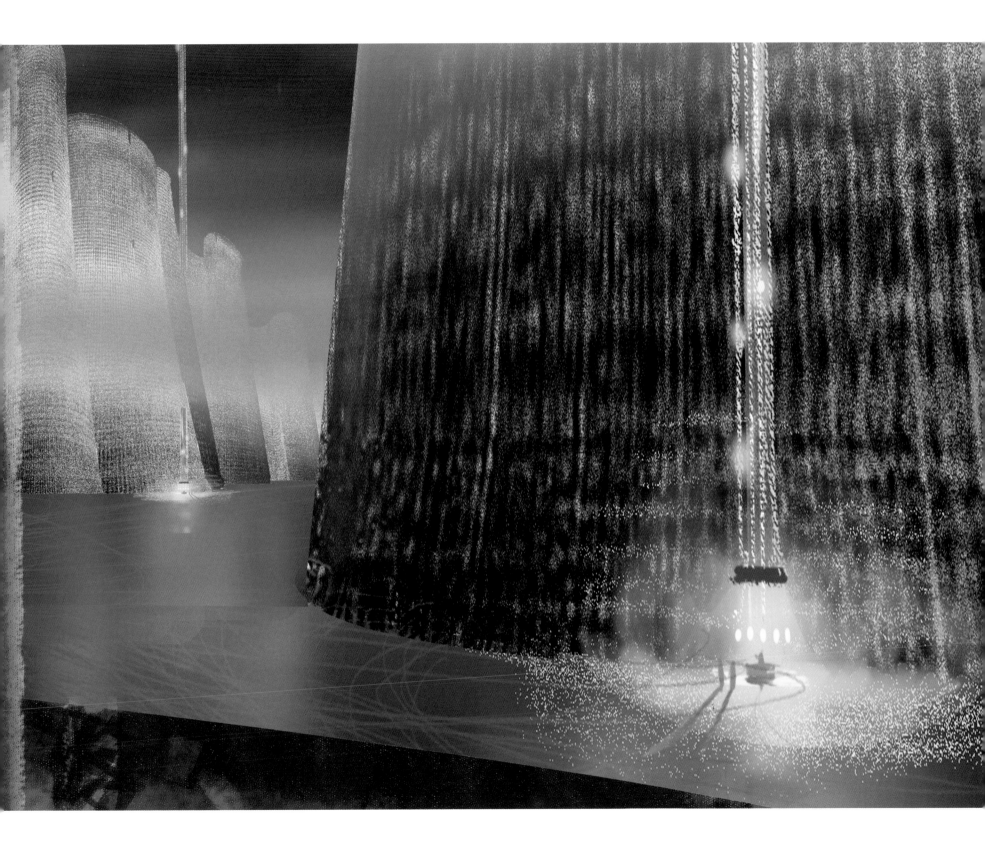

TOP
BILL CONE Digital

BOTTOM
RALPH EGGLESTON Digital painting

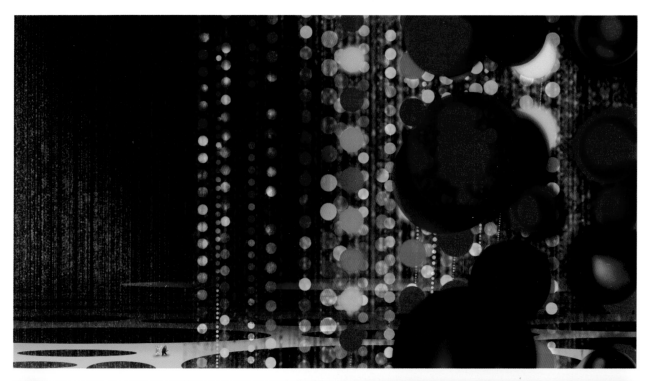

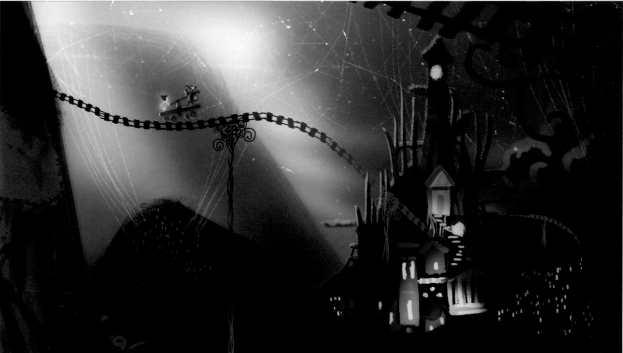

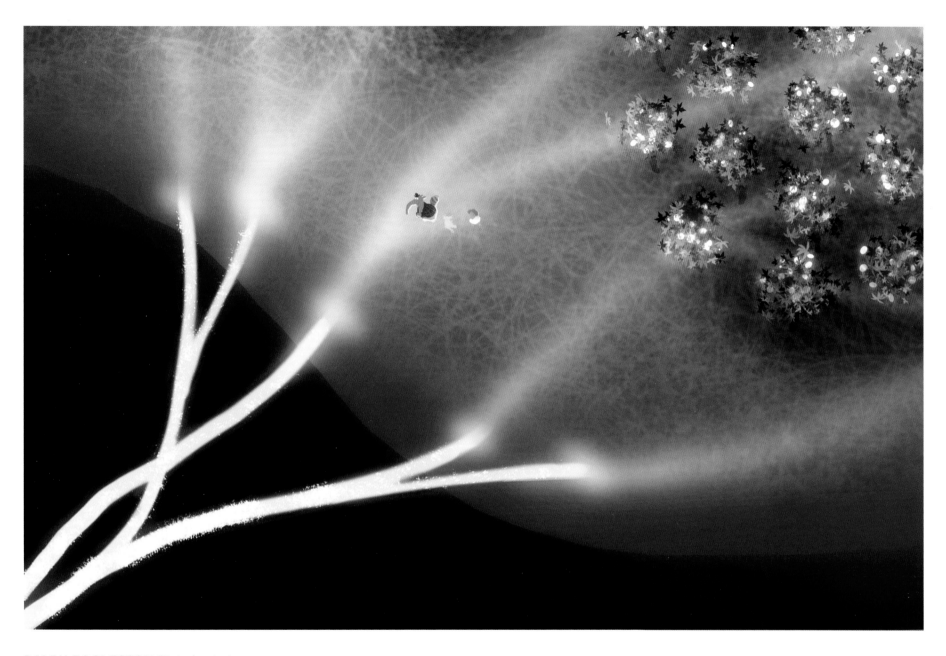

RALPH EGGLESTON Digital painting

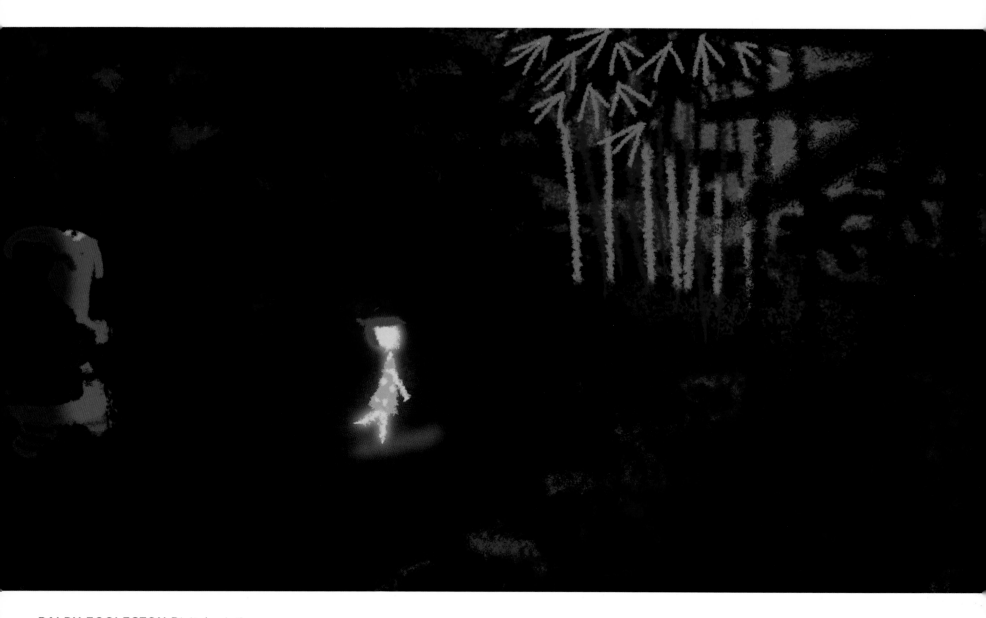

RALPH EGGLESTON Digital painting

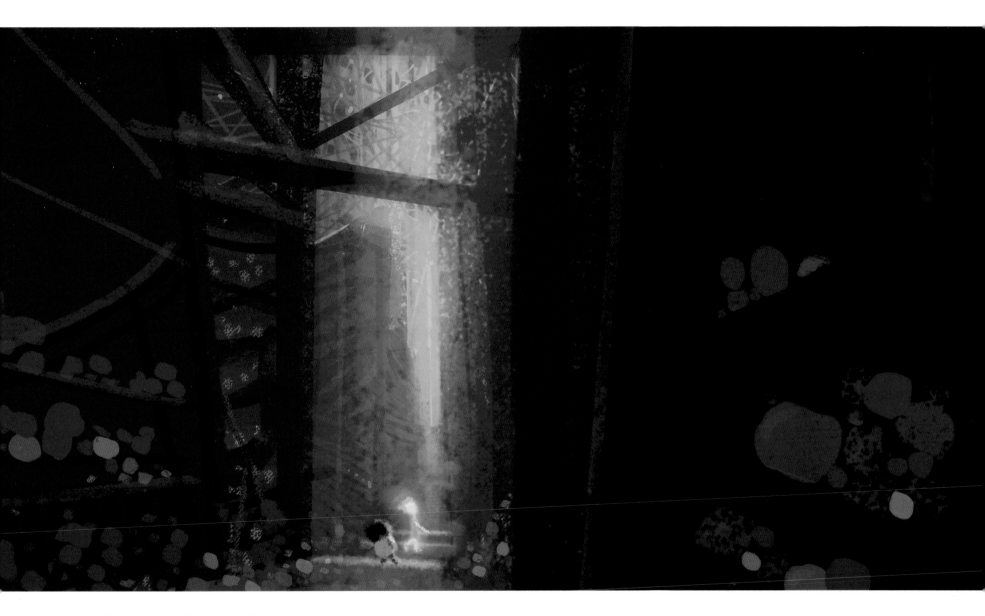

BILL CONE and RALPH EGGLESTON Digital painting

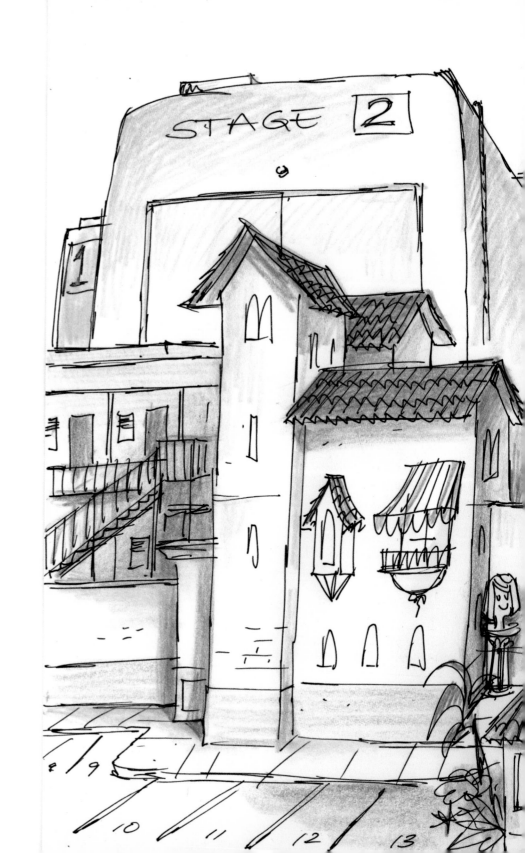

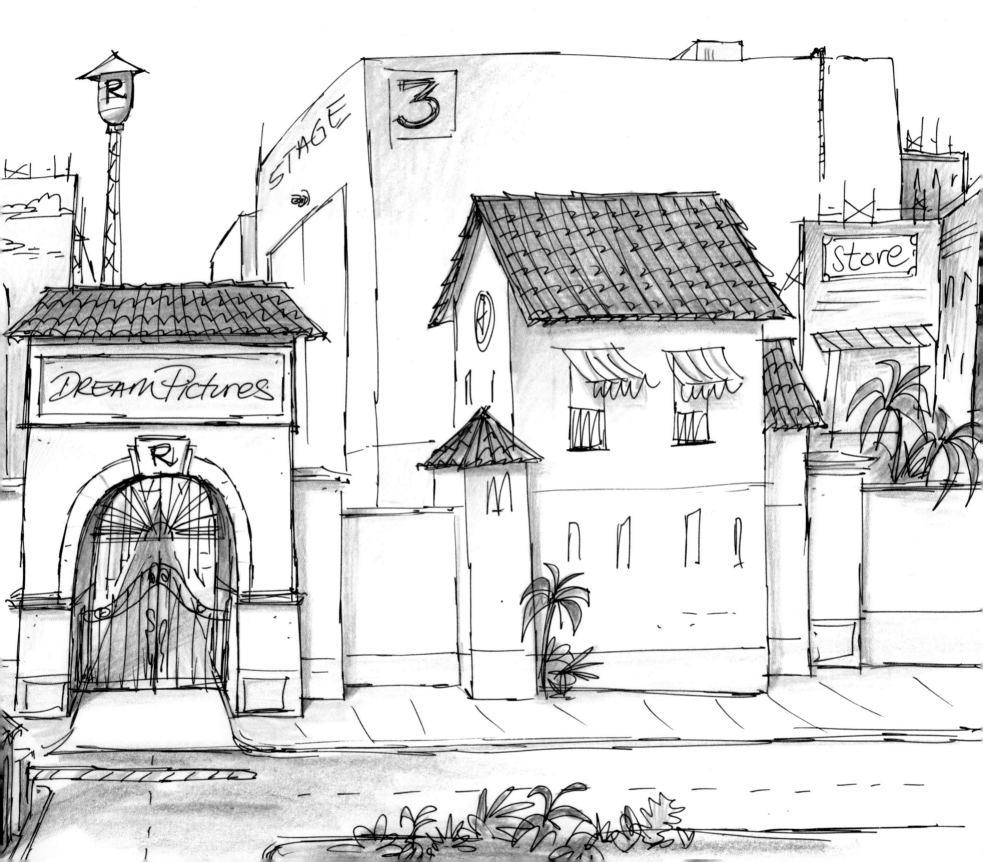

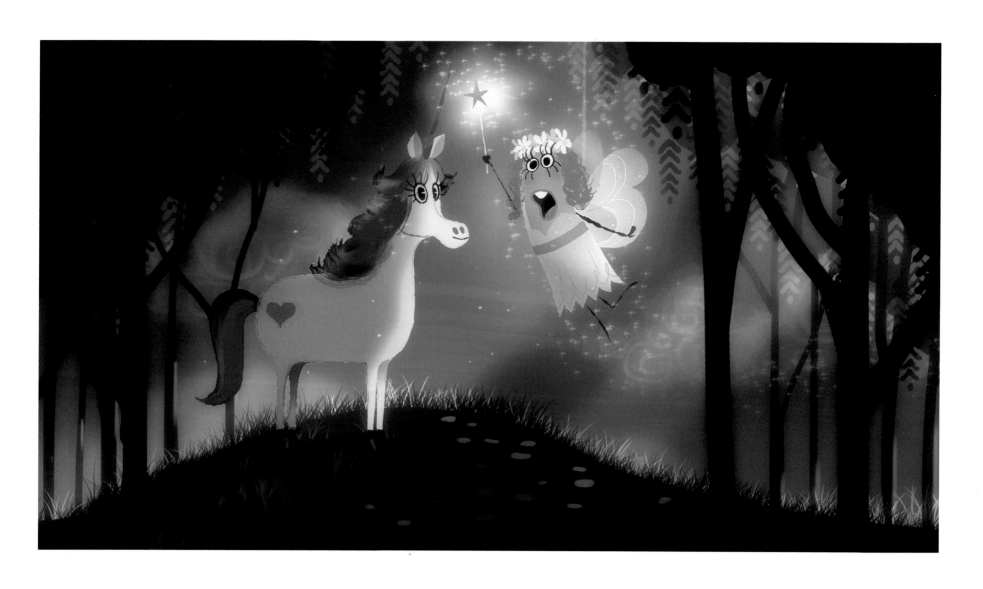

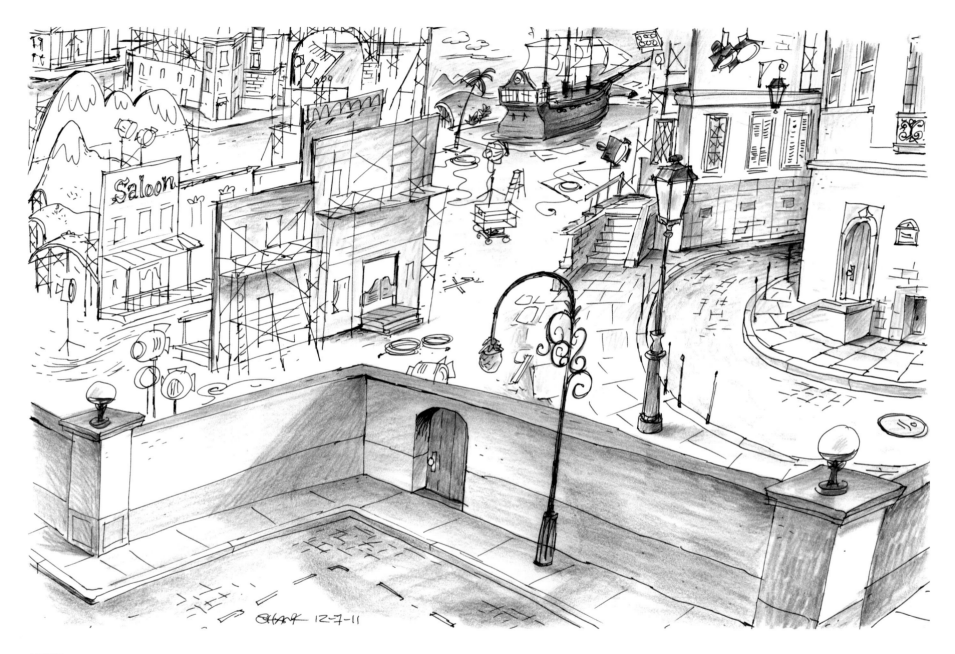

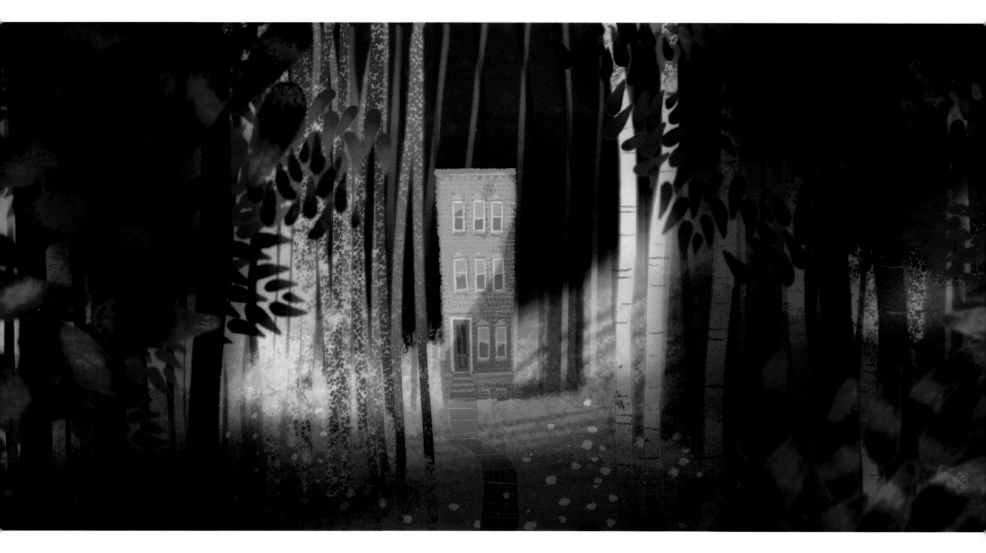

ABOVE
RALPH EGGLESTON Digital painting

An early version of Riley's subconscious.

OPPOSITE
RONNIE DEL CARMEN Marker and pencil

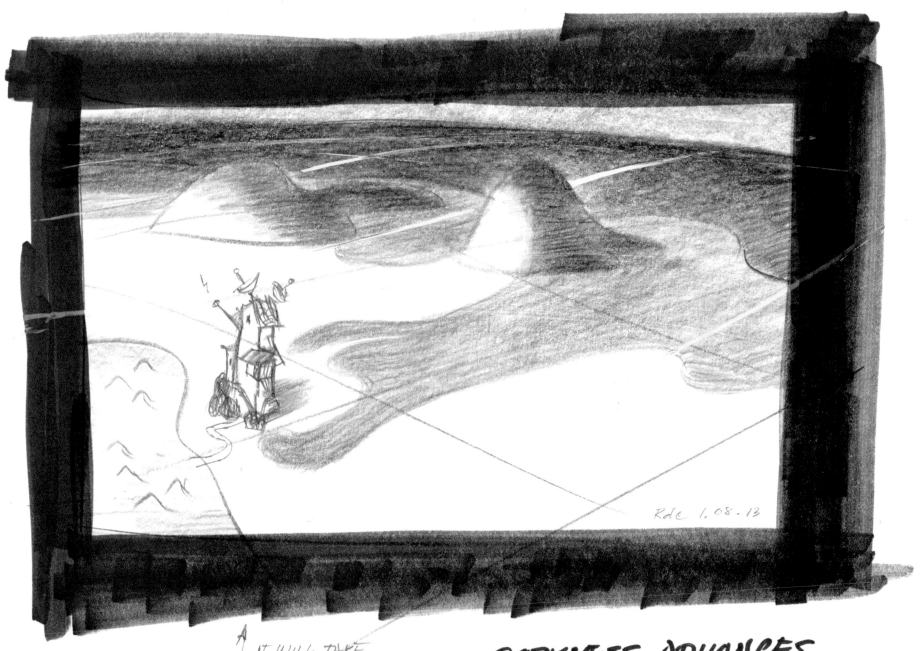

It will take
out buildings
parts of Riley's
Mind

DARKNESS ADVANCES
not in a strict
concentric Circle

Rde 1.08.13

Rde Jan 08.13

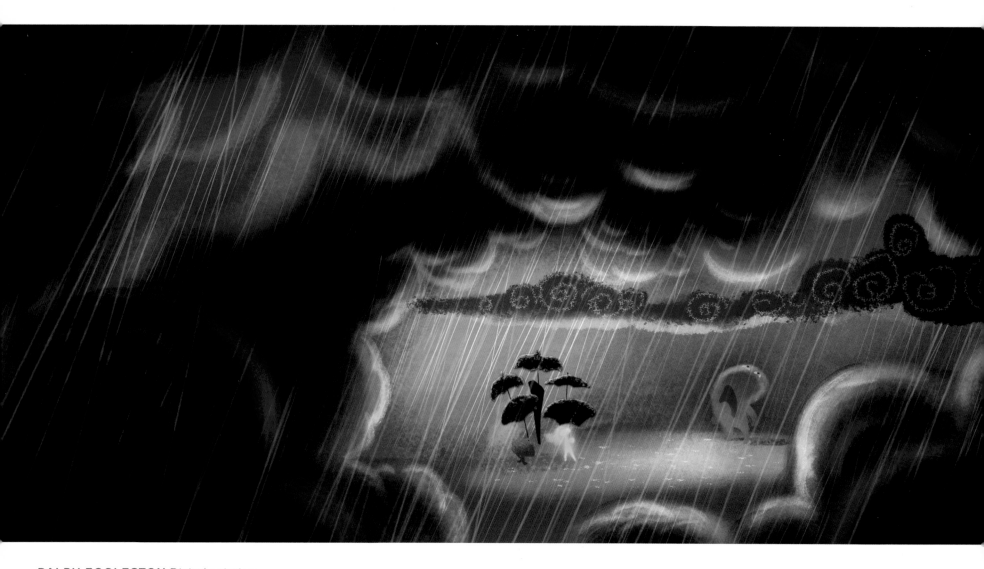

RALPH EGGLESTON Digital painting

Caught in a brainstorm.

DAN HOLLAND Marker and watercolor

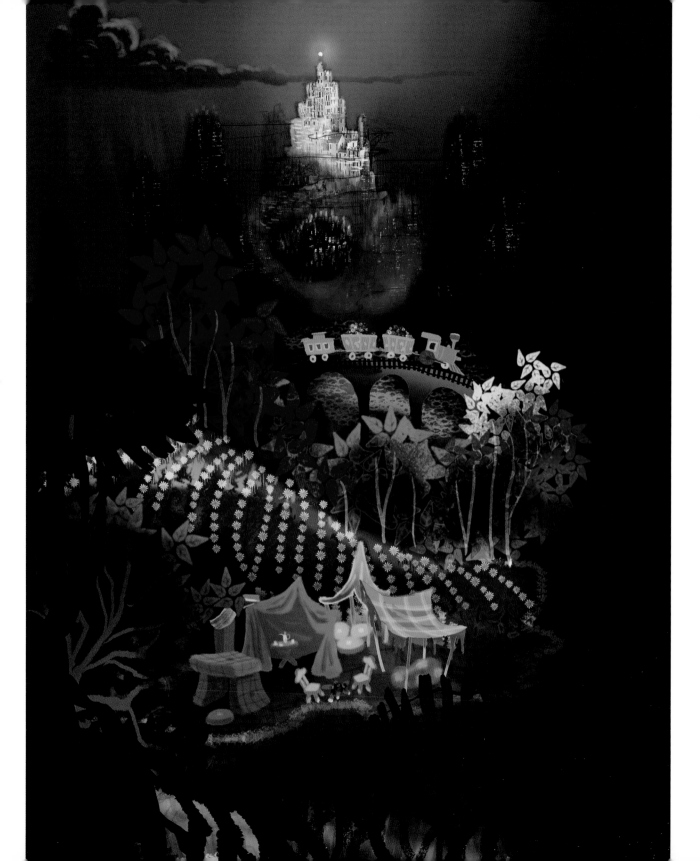

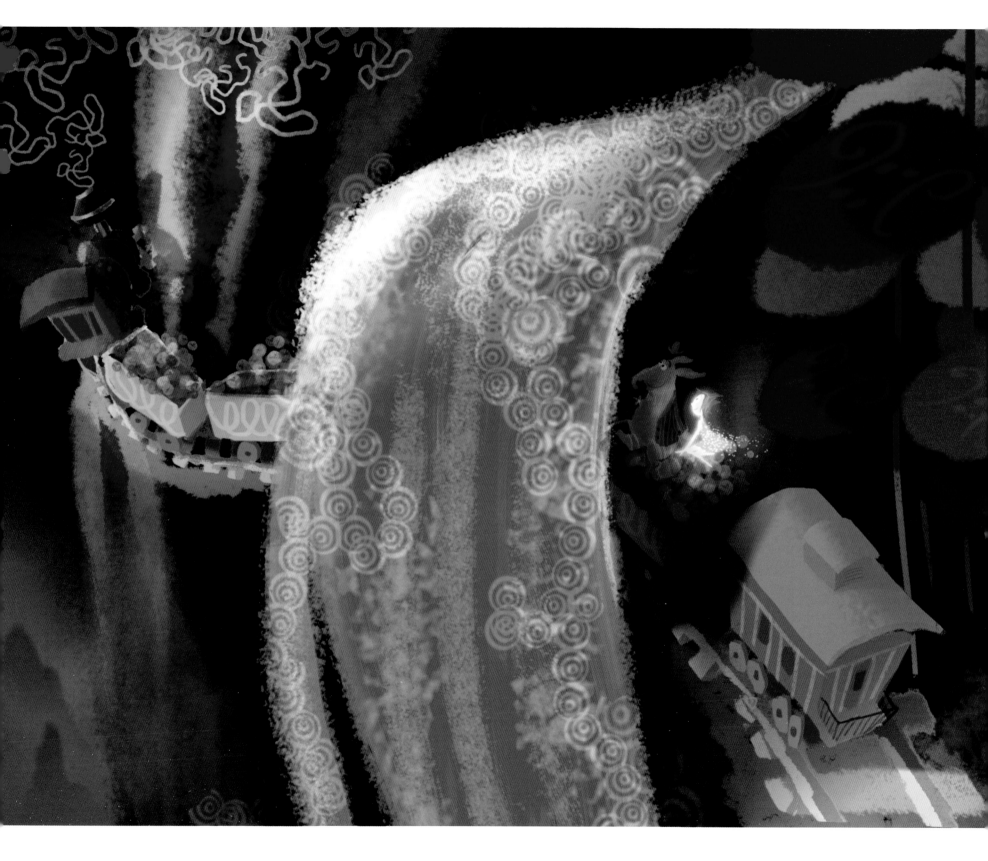

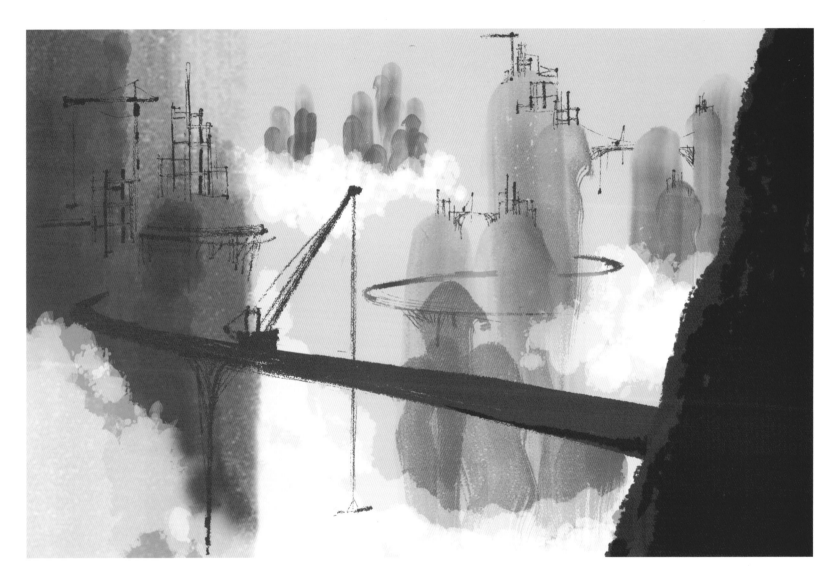

DAN HOLLAND
Watercolor and digital painting

The Mind World visualized as hills rising from
the mists of unconsciousness.

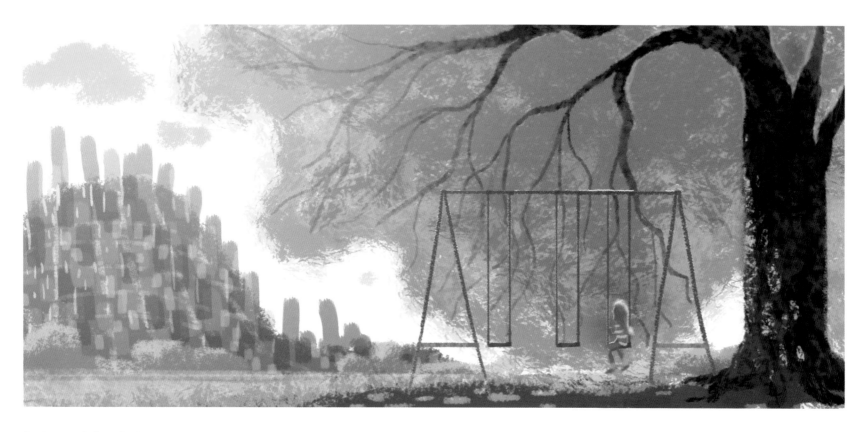

RALPH EGGLESTON Digital painting

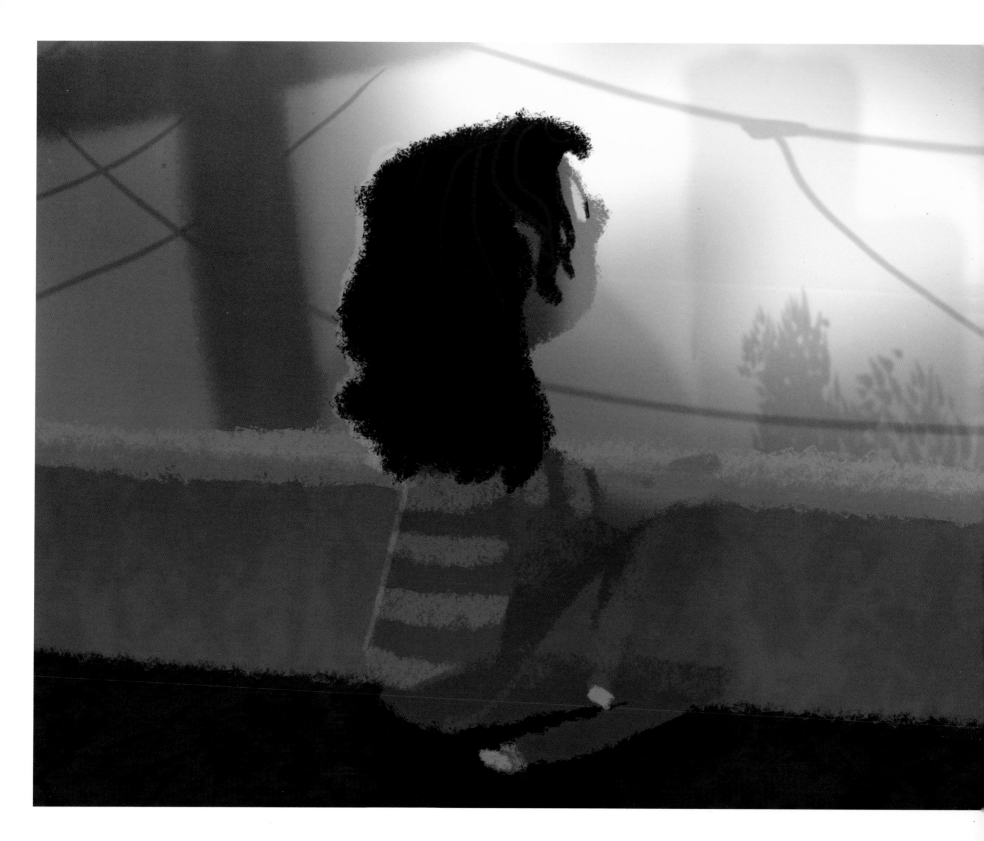

RALPH EGGLESTON
Digital painting

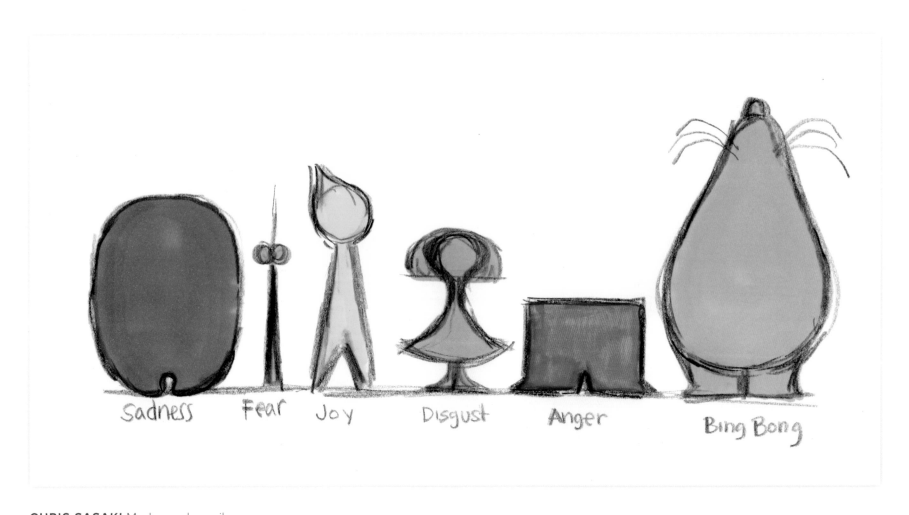

Sadness Fear Joy Disgust Anger Bing Bong

CHRIS SASAKI Marker and pencil

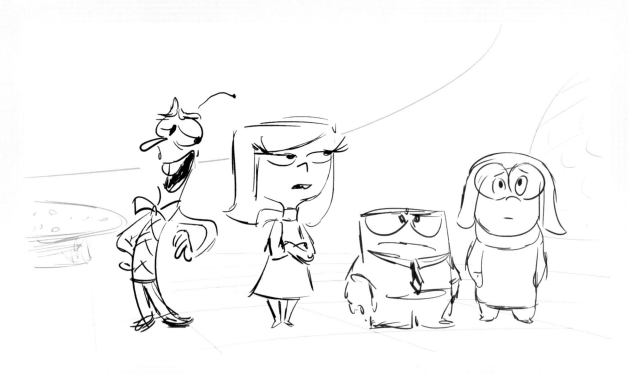

VLAD KOOPERMAN Digital

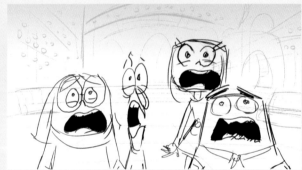
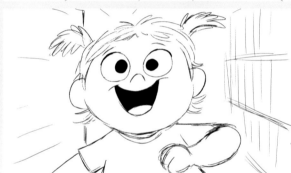

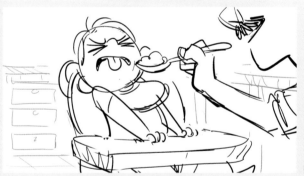
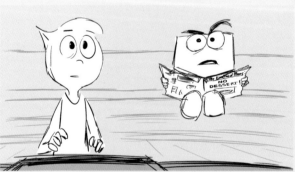

LEFT TO RIGHT, TOP TO BOTTOM
RONNIE DEL CARMEN
JOSH COOLEY
YUNG-HAN CHANG
GARETT SHELDREW
TONY ROSENAST
TONY ROSENAST
DOMEE SHI
VLAD KOOPERMAN/TONY ROSENAST
All artwork digital

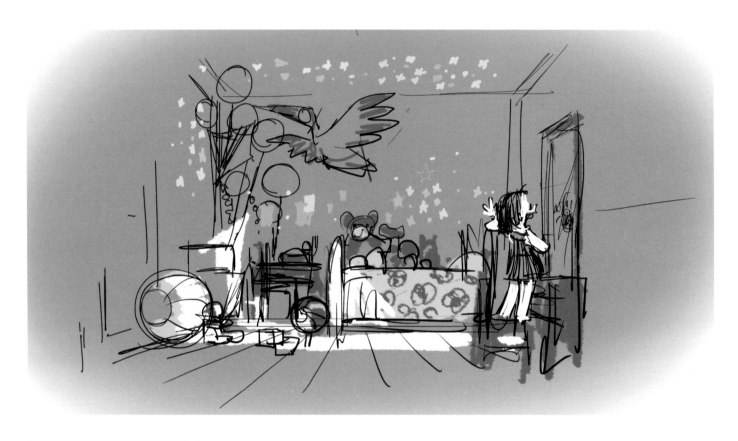

RONNIE DEL CARMEN Digital

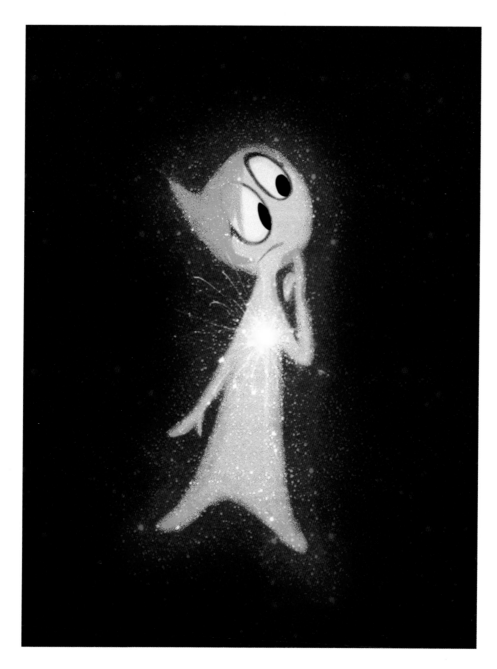

ALBERT LOZANO
Digital painting

DANIEL ARRIAGA
Digital painting

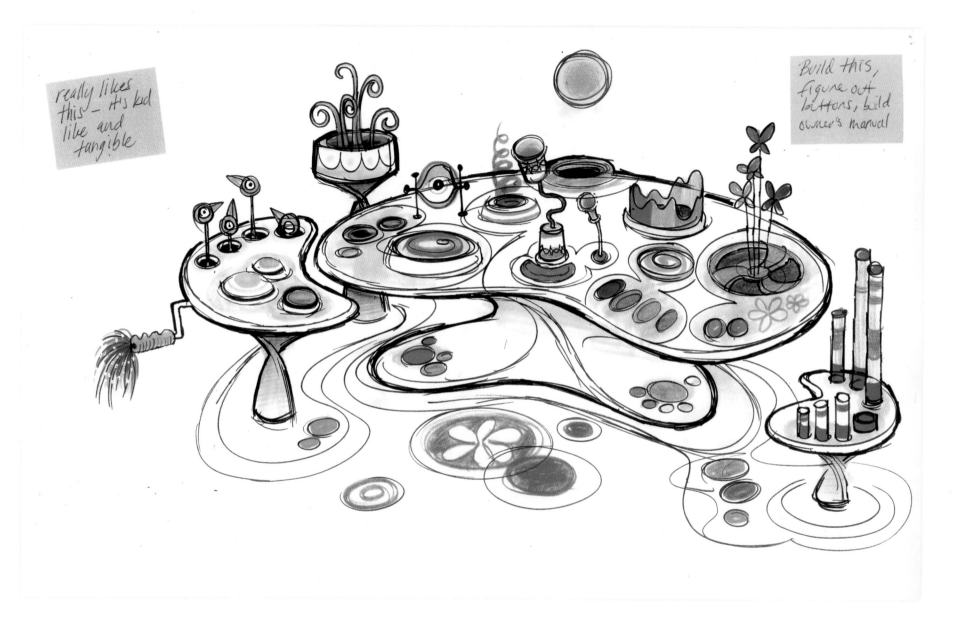

ABOVE
DAN HOLLAND Colored pencil, marker and ink

OPPOSITE
DAN HOLLAND Marker, colored pencil, and white out

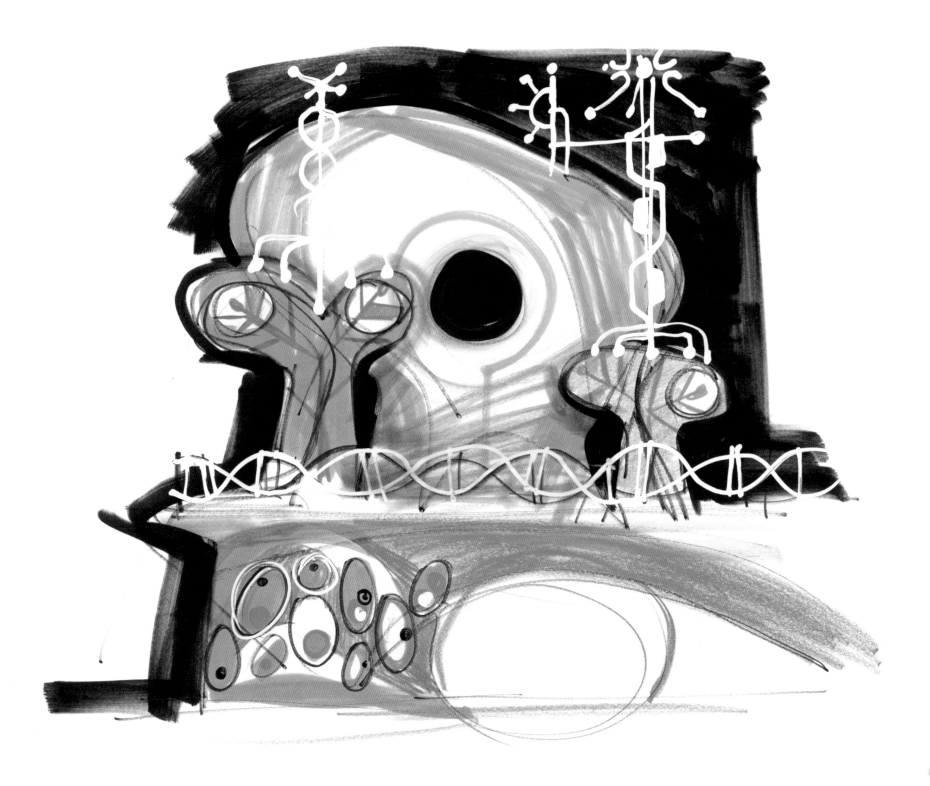

RALPH EGGLESTON Digital painting

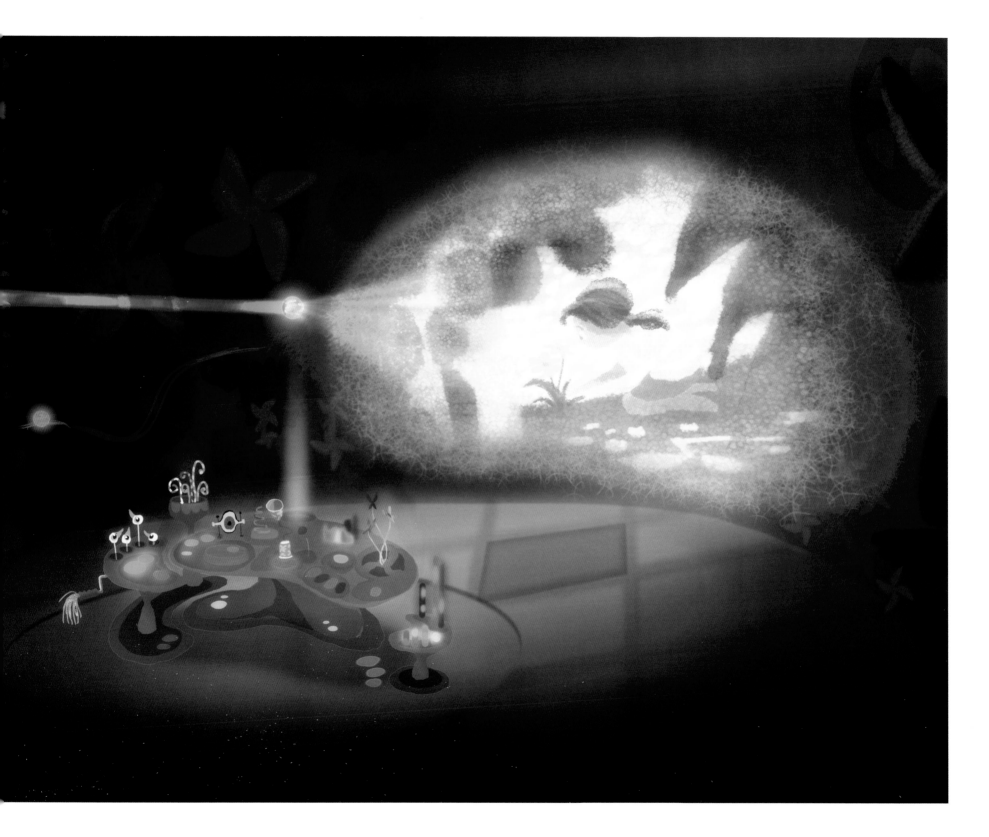

RONNIE DEL CARMEN Pencil

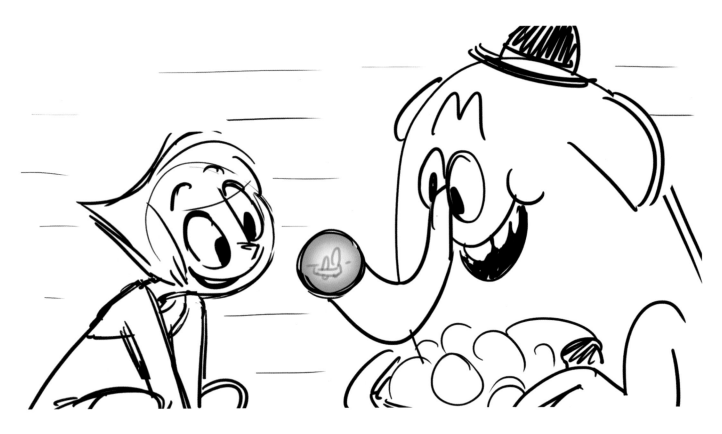

DOMEE SHI Digital

RALPH EGGLESTON Digital painting

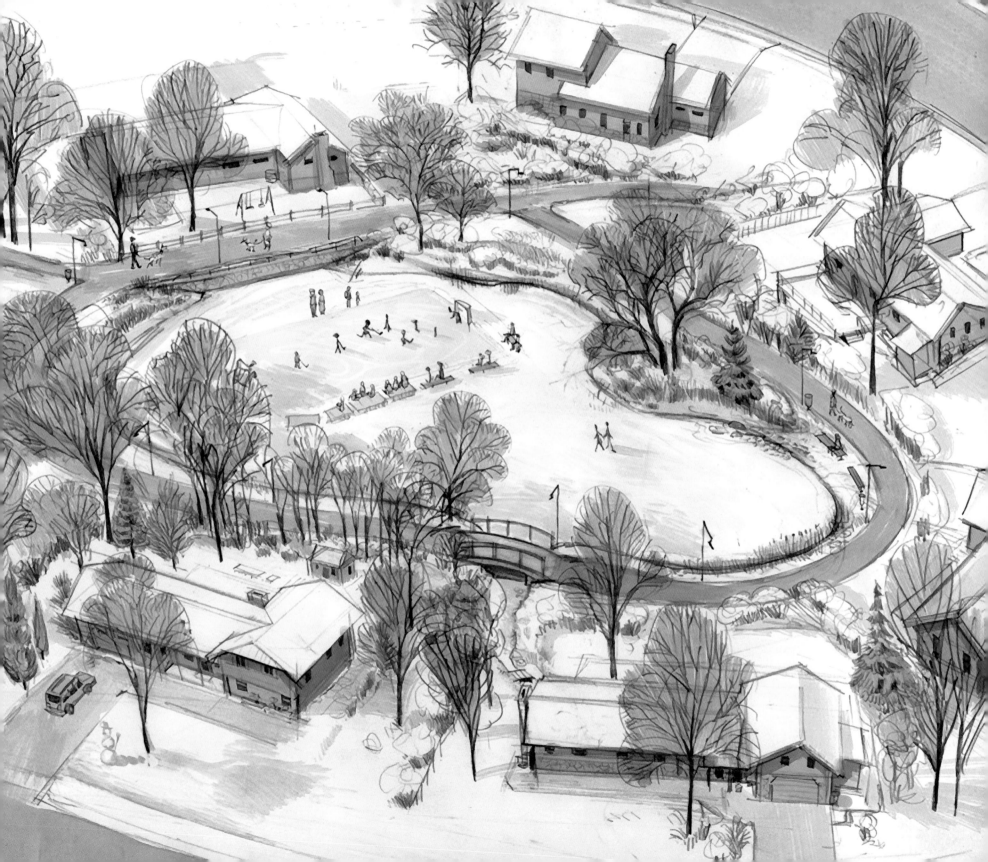

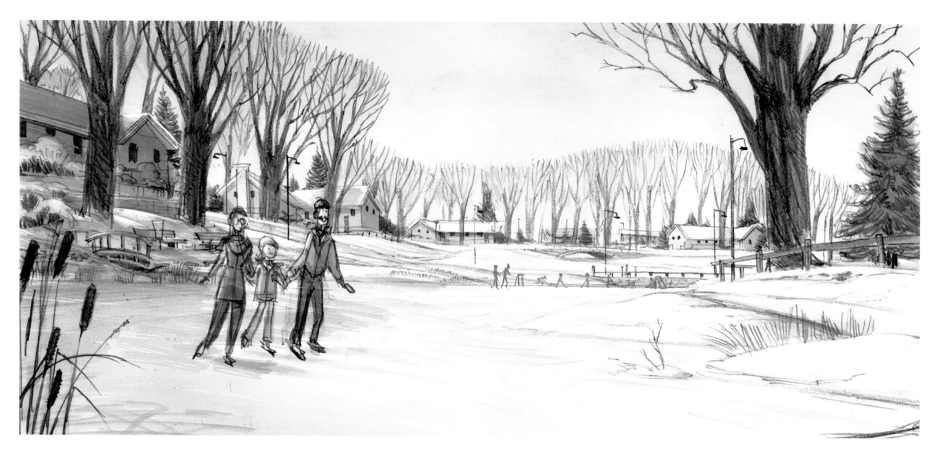

KRISTIAN NORELIUS Digital painting and pencil

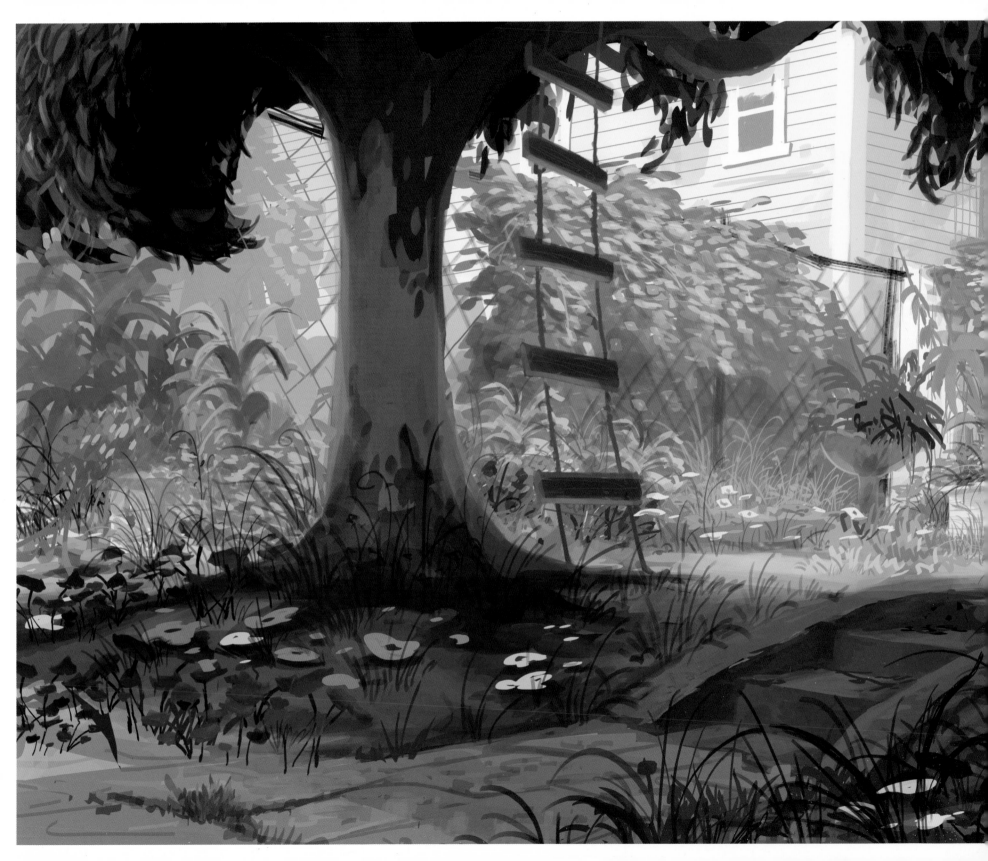

JOHN NEVAREZ
Digital painting

93

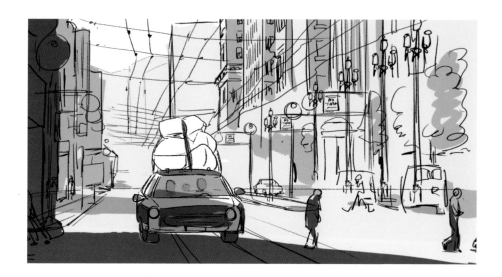

ABOVE
SHION TAKEUCHI Digital

RIGHT
KRISTIAN NORELIUS Digital painting and pencil

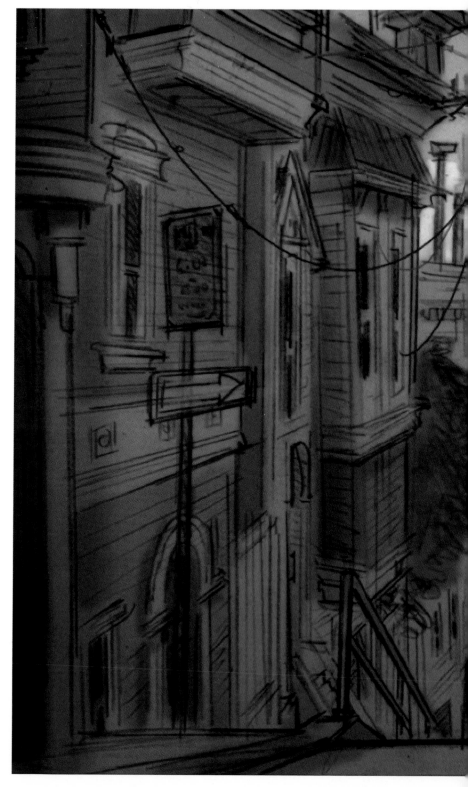

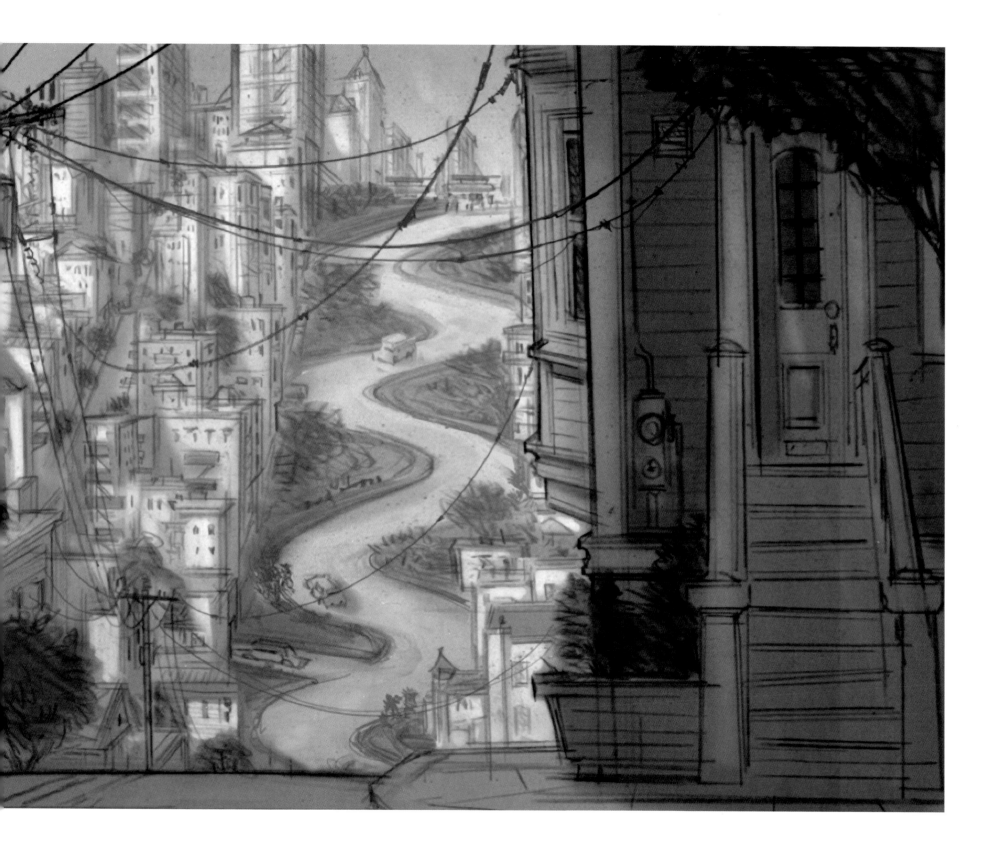

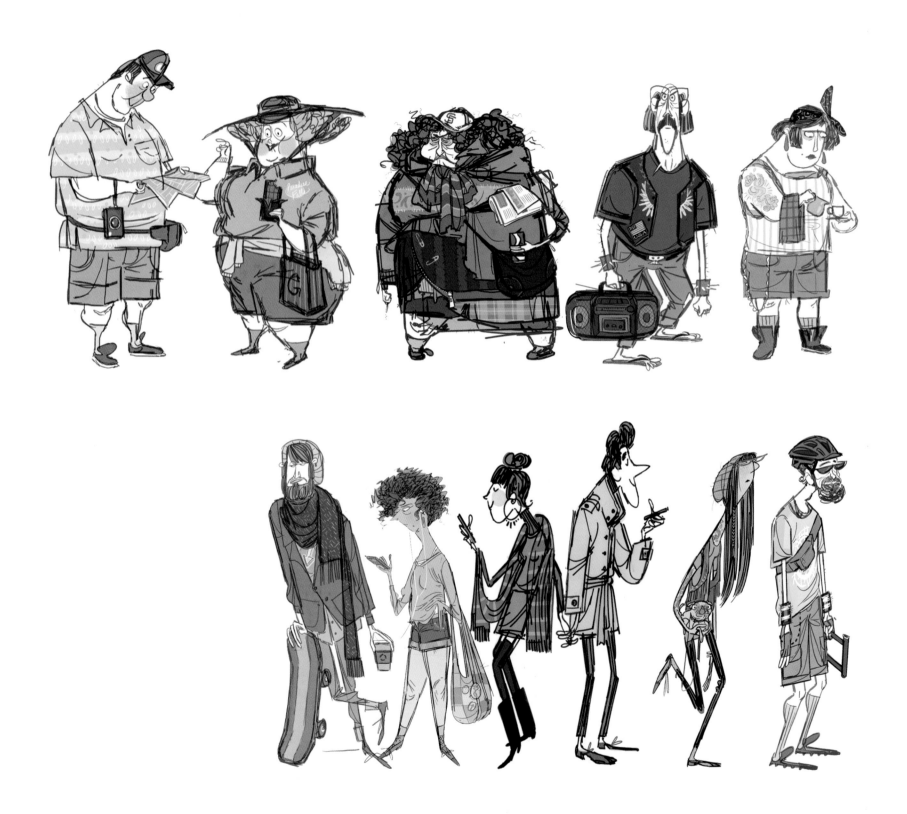

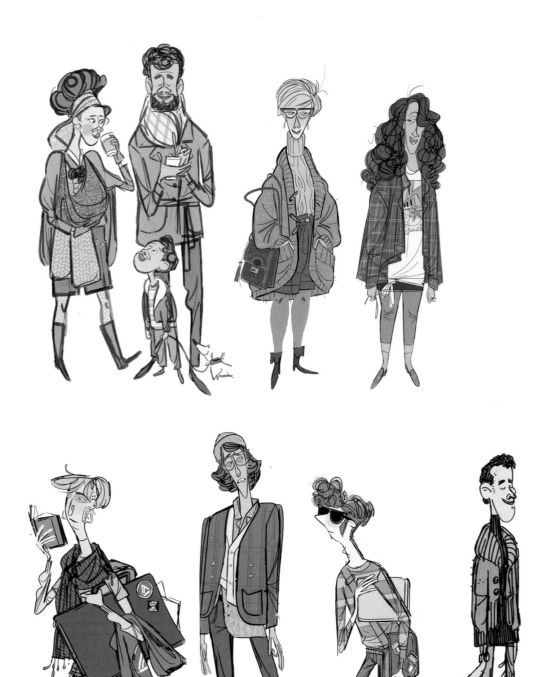

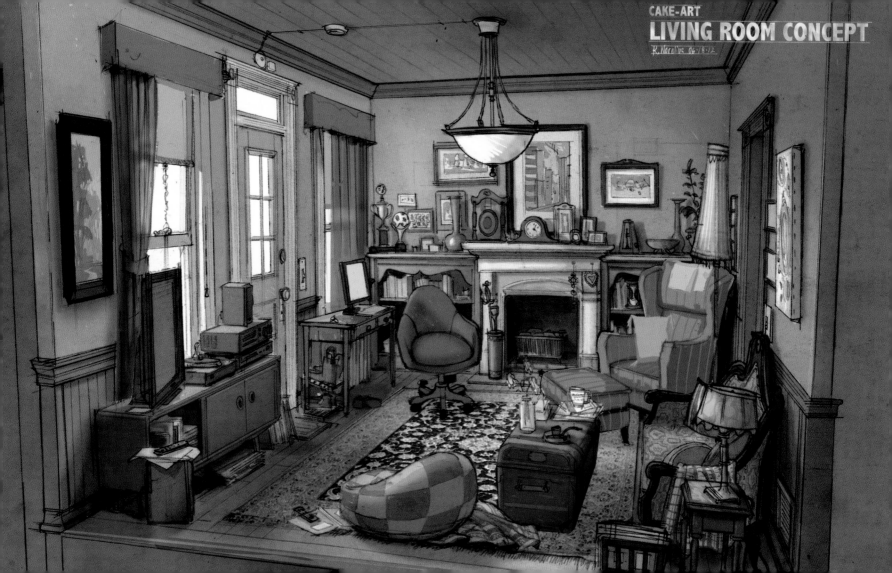

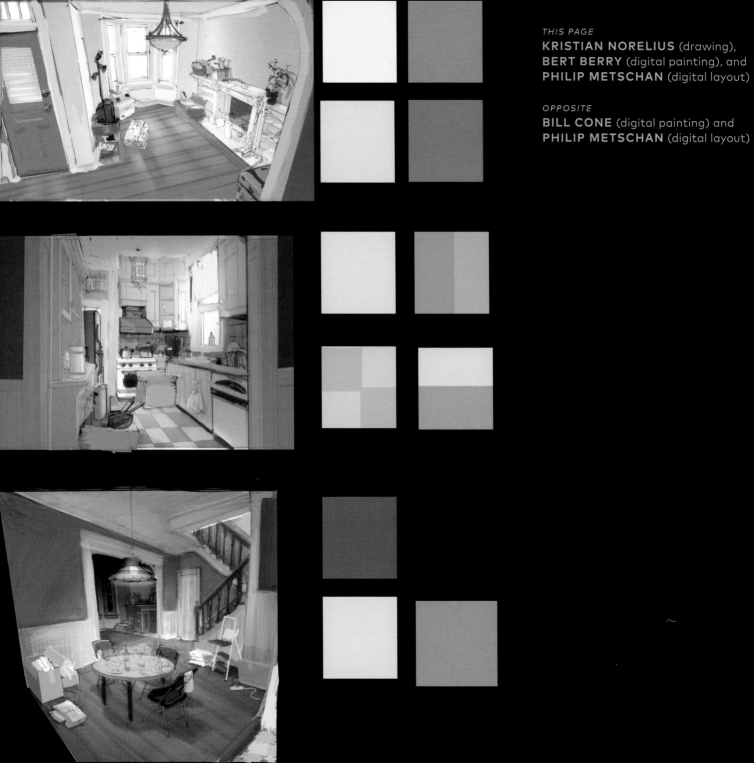

THIS PAGE
KRISTIAN NORELIUS (drawing),
BERT BERRY (digital painting), and
PHILIP METSCHAN (digital layout)

OPPOSITE
BILL CONE (digital painting) and
PHILIP METSCHAN (digital layout)

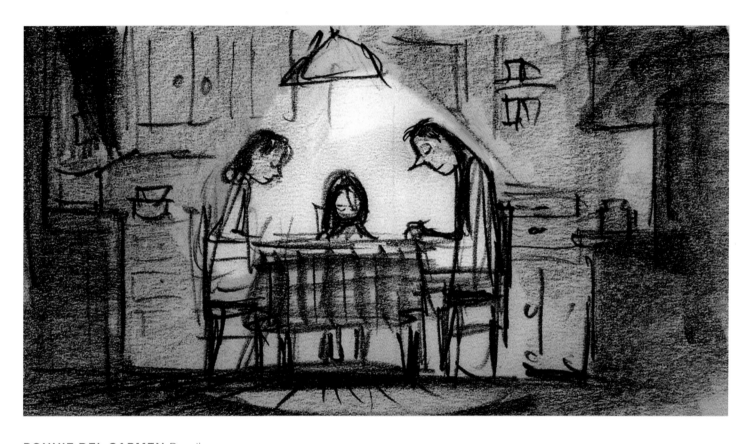

RONNIE DEL CARMEN Pencil

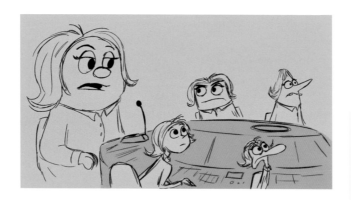

TONY ROSENAST Digital

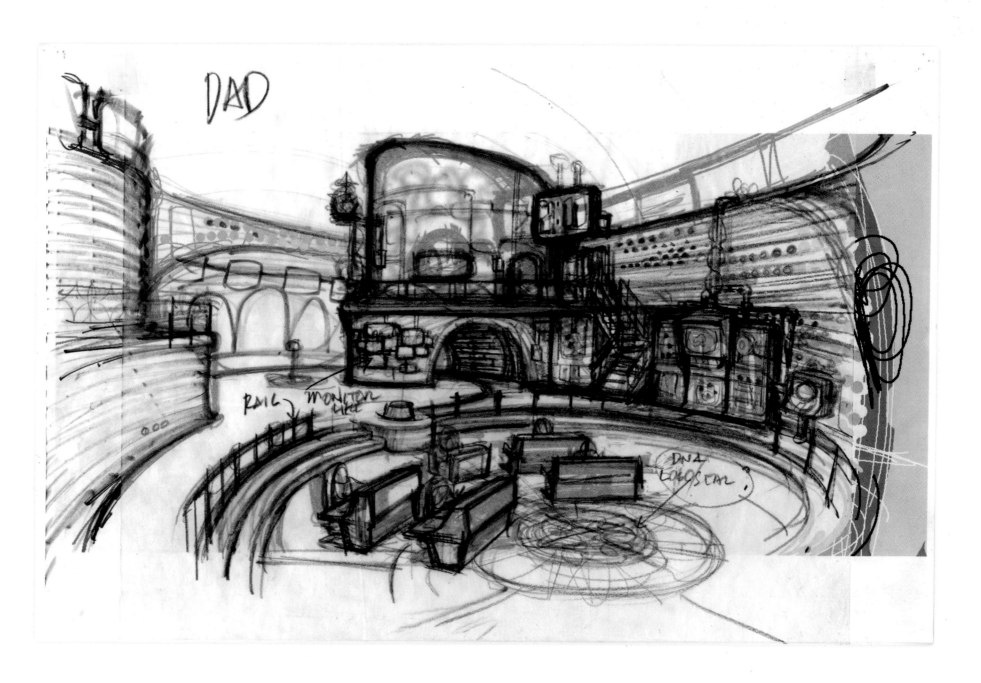

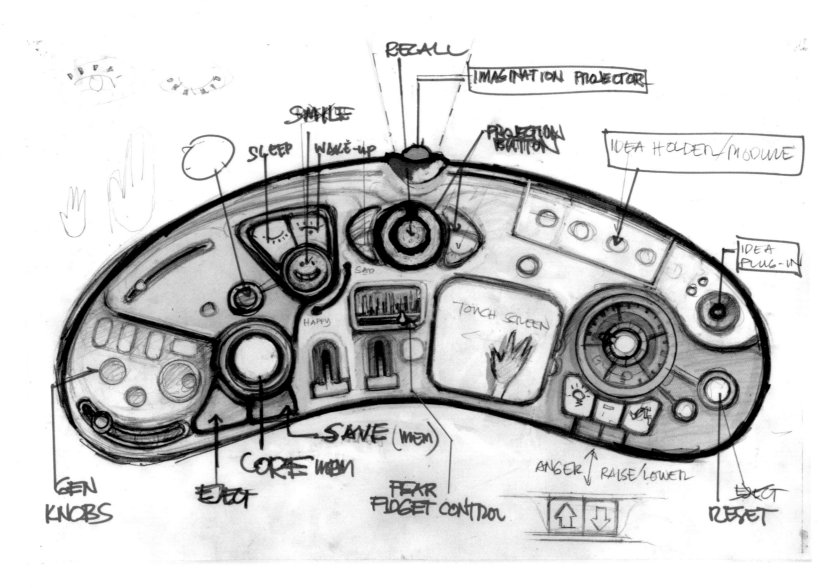

RECALL

IMAGINATION PROJECTOR

SPARKLE

SLEEP WAKE-UP

PROJECTION BUTTON

IDEA HOLDER/MODULE

IDEA PLUG-IN

SAD

HAPPY

TOUCH SCREEN

ANGER RAISE/LOWER

SAVE (mem)

CORE mem

EJECT

FEAR FIDGET CONTROL

GEN KNOBS

EJECT RESET

ABOVE AND OPPOSITE
NELSON BOHOL and PHILIP METSCHAN (digital layout)
Pencil and pen

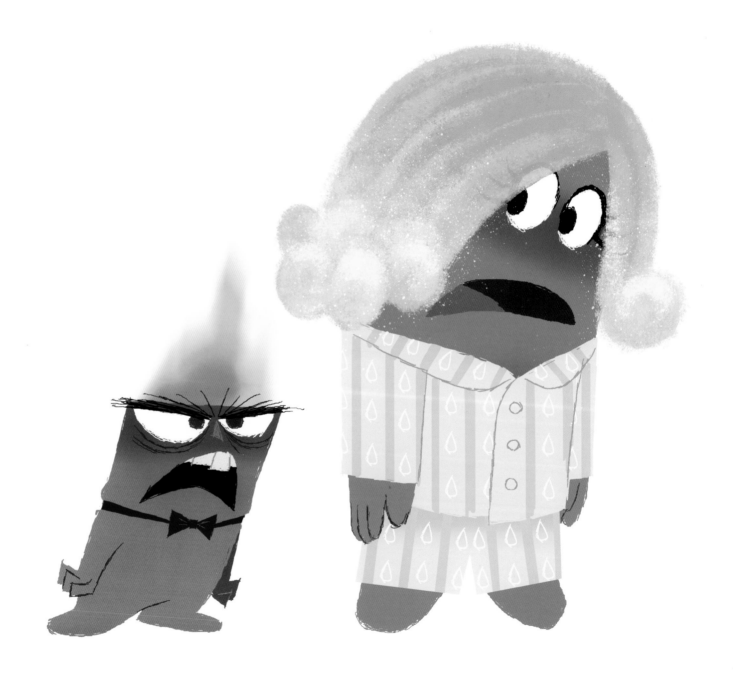

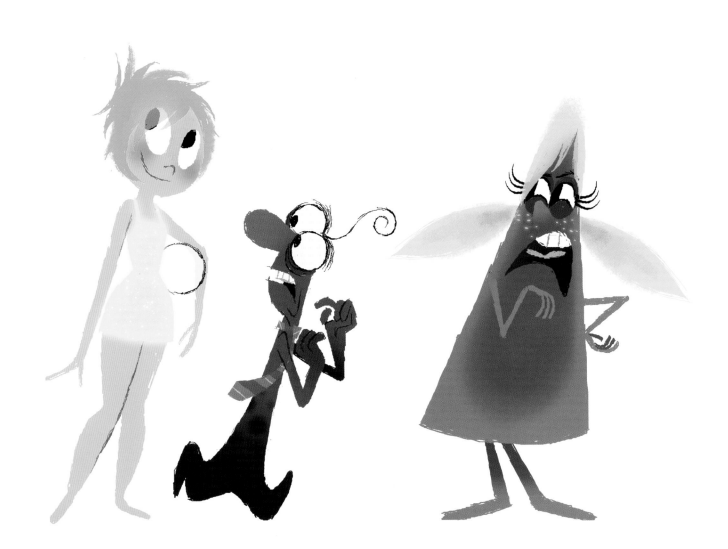

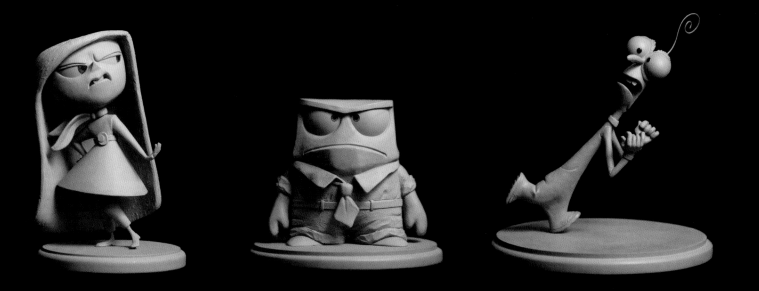
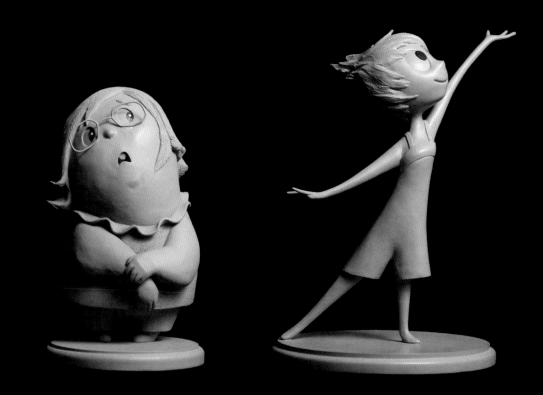

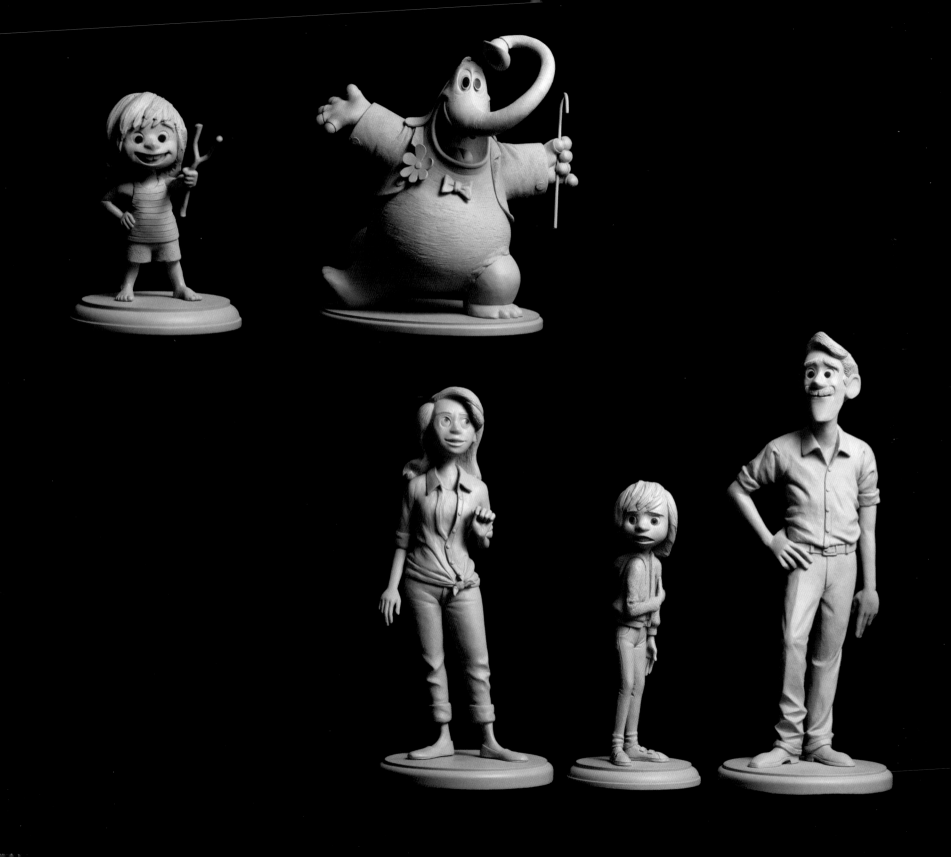

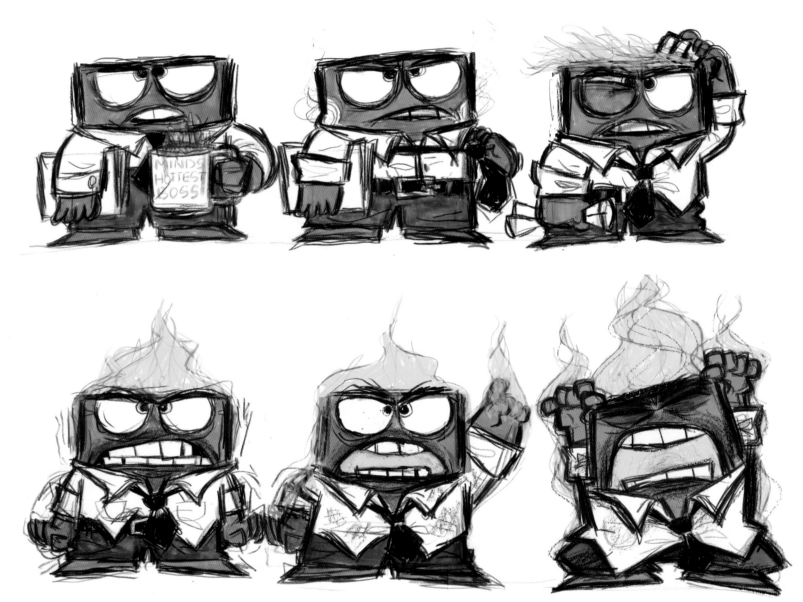

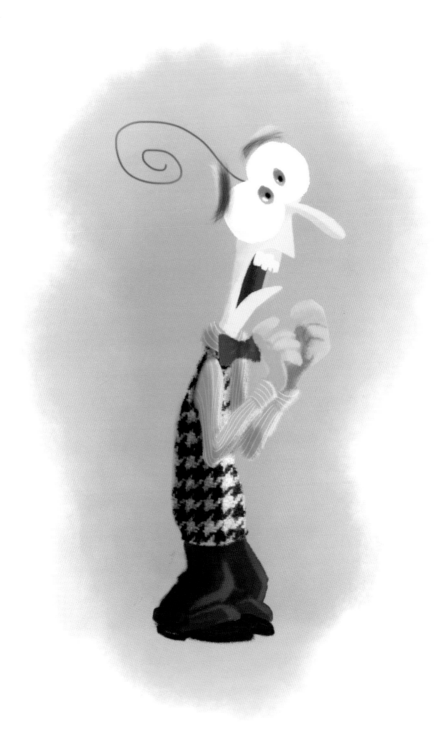

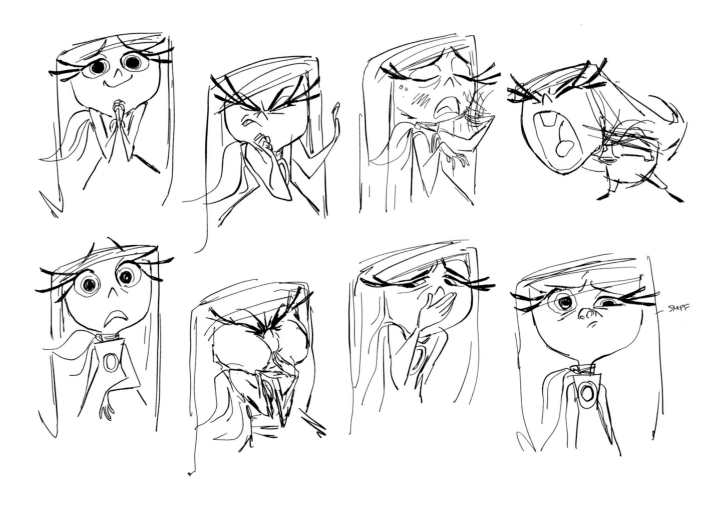

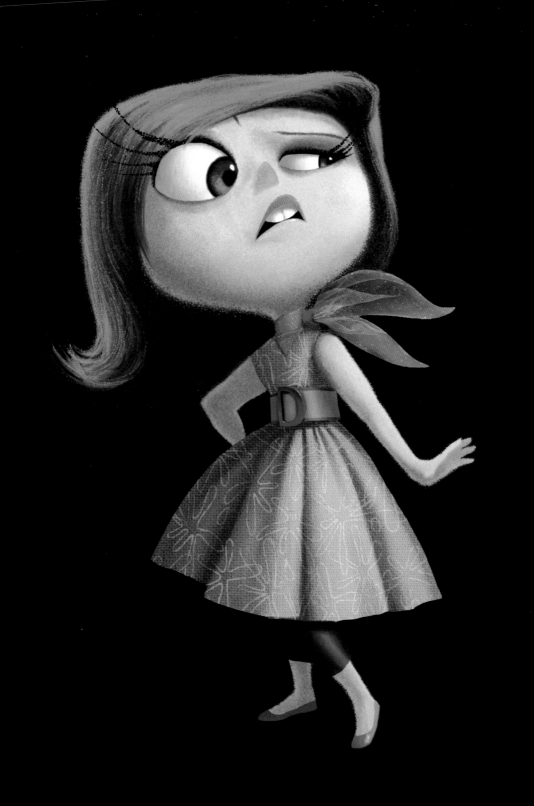

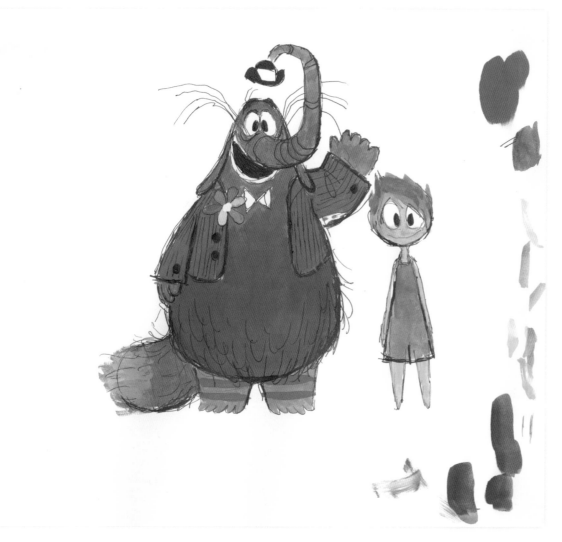

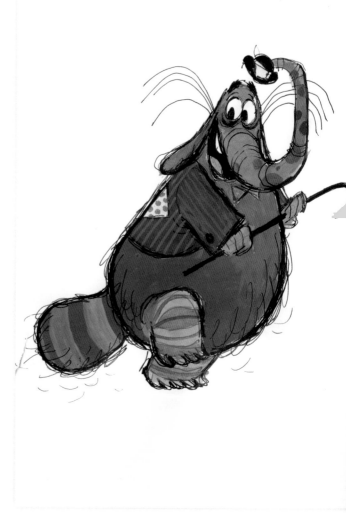

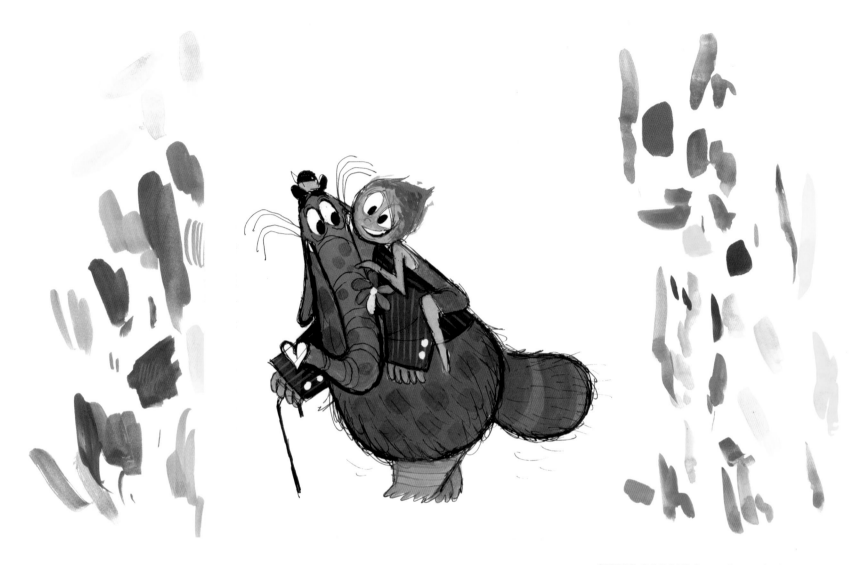

CHRIS SASAKI Gouache and ink

Bing Bong was one of several imaginary friends we
came up with; ultimately the others weren't useful to
the storytelling and didn't make the final cut.

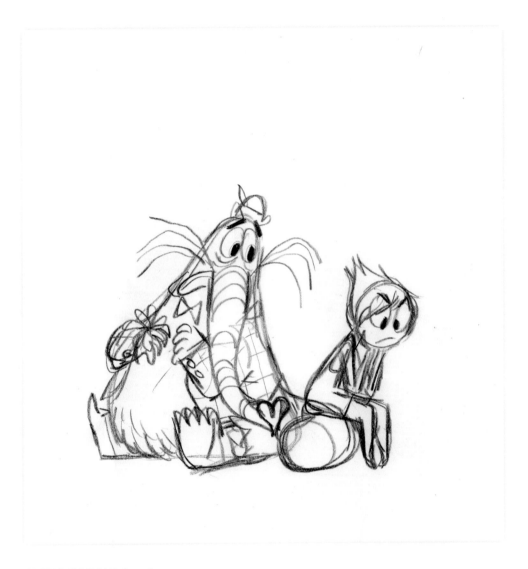

CHRIS SASAKI Pencil

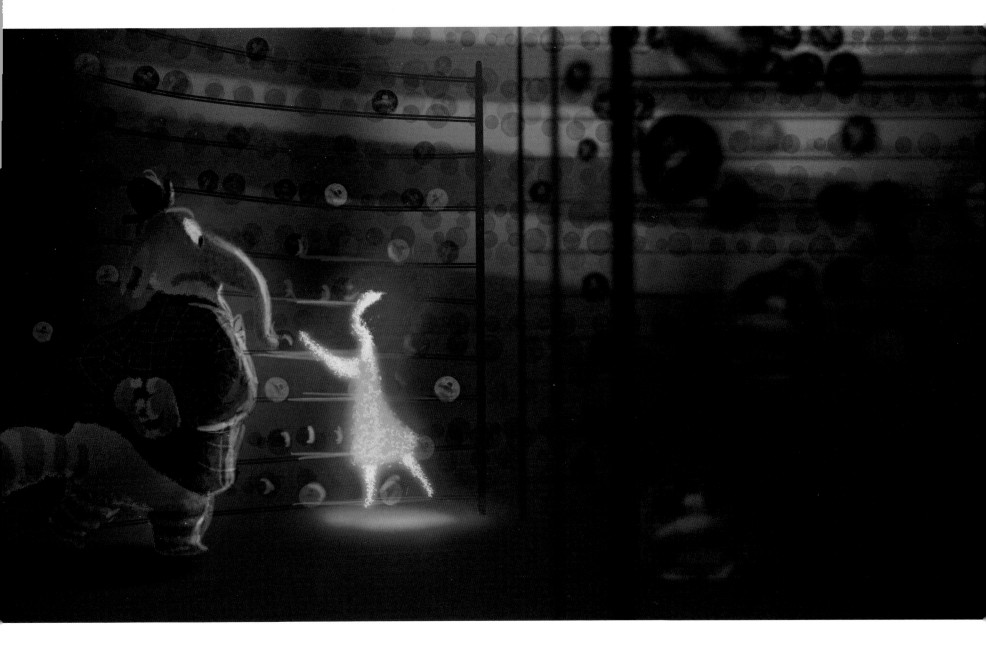

RALPH EGGLESTON Digital painting

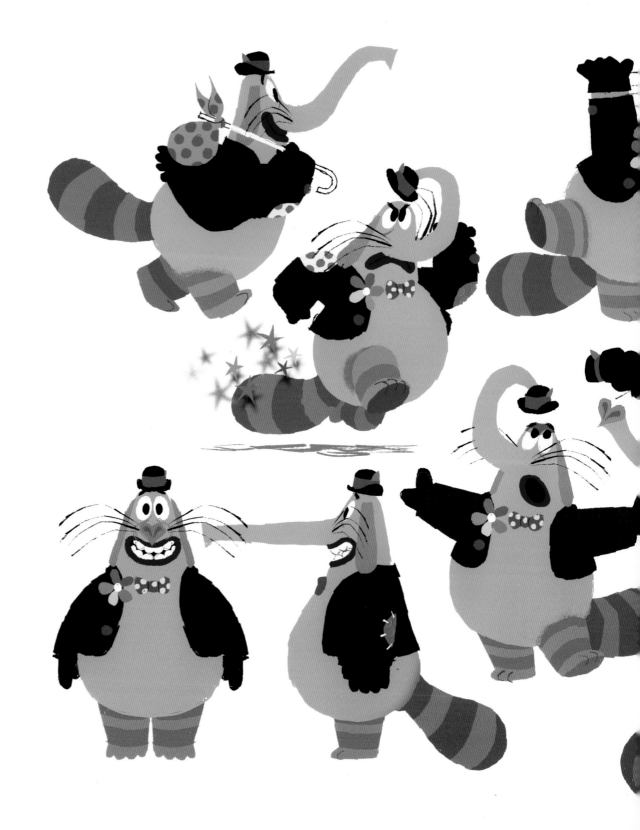

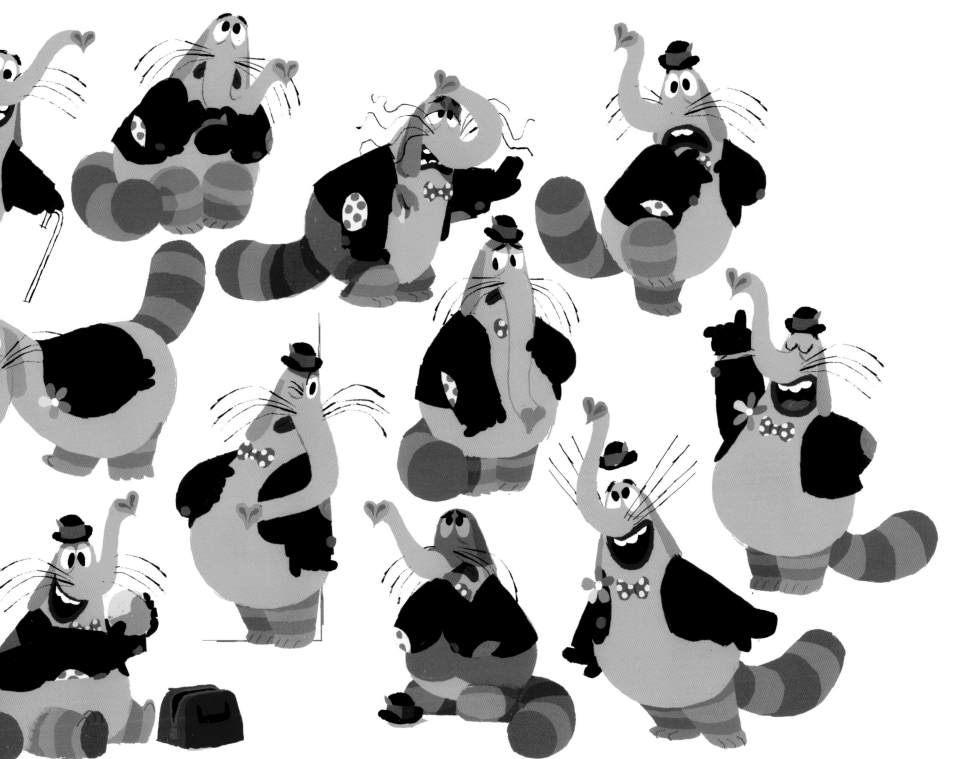

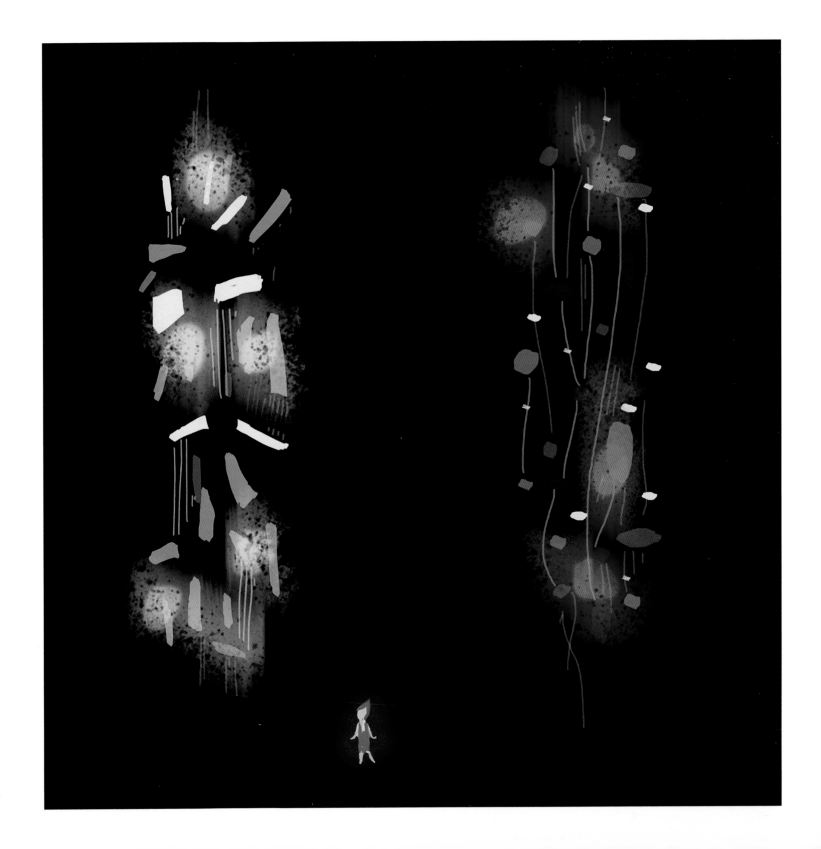

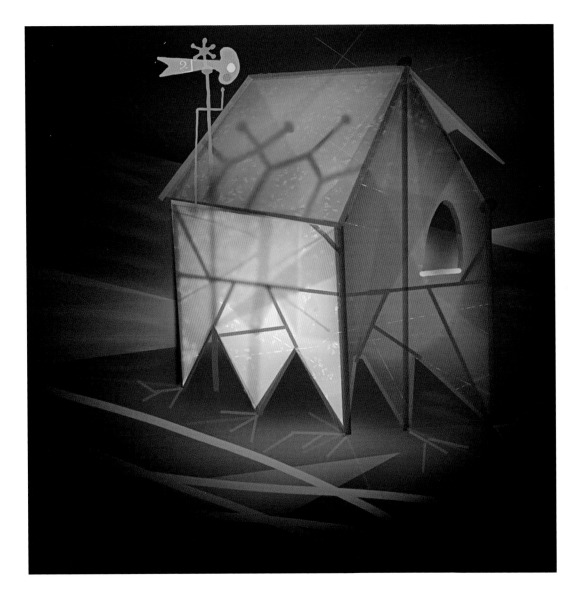

ABOVE AND OPPOSITE
DAN HOLLAND (layout) **and BERT BERRY** (digital painting)

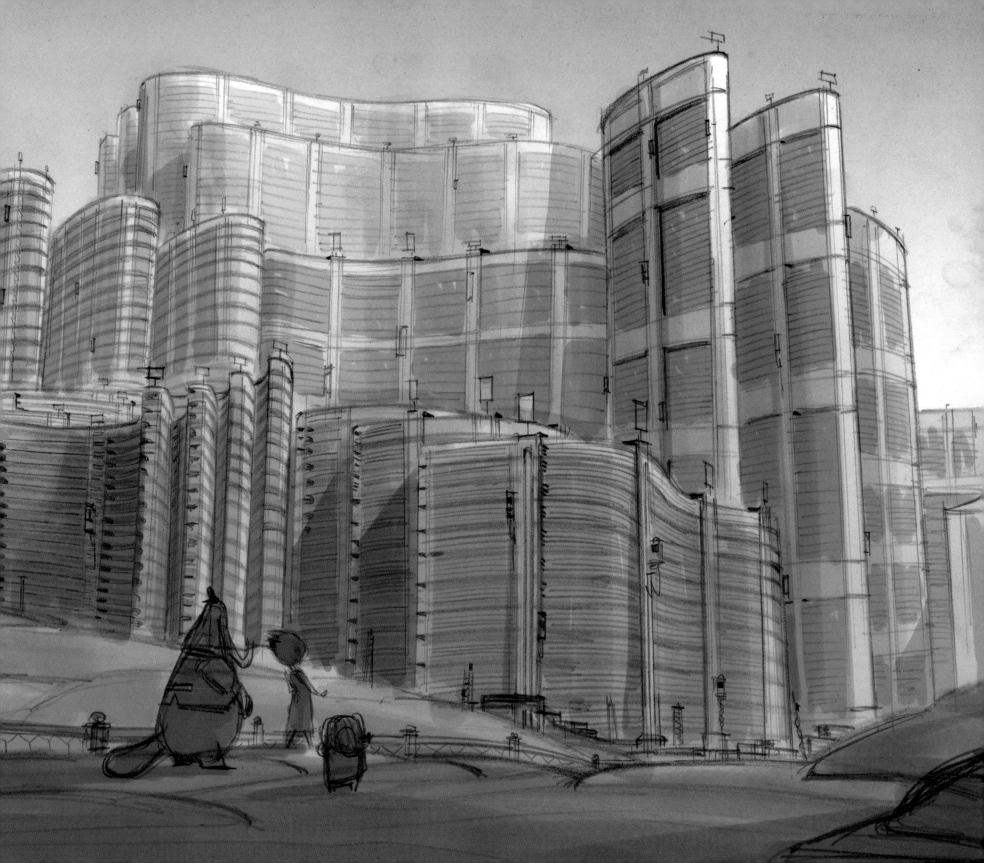

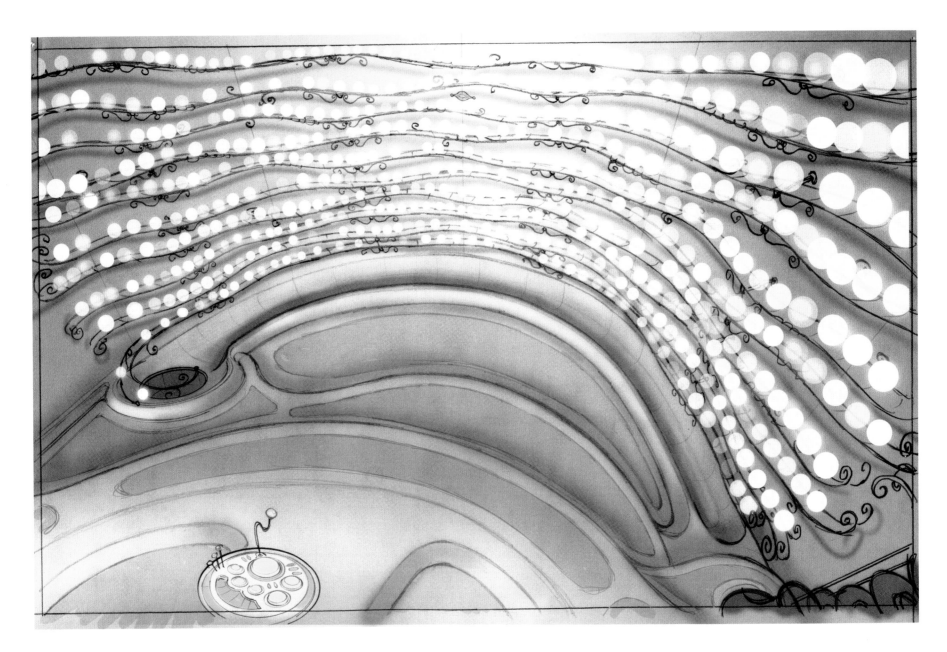

ABOVE
KRISTIAN NORELIUS and **PHILIP METSCHAN** (digital layout)
Digital painting

OPPOSITE
KRISTIAN NORELIUS and **PHILIP METSCHAN** (digital layout)
Pencil and digital painting

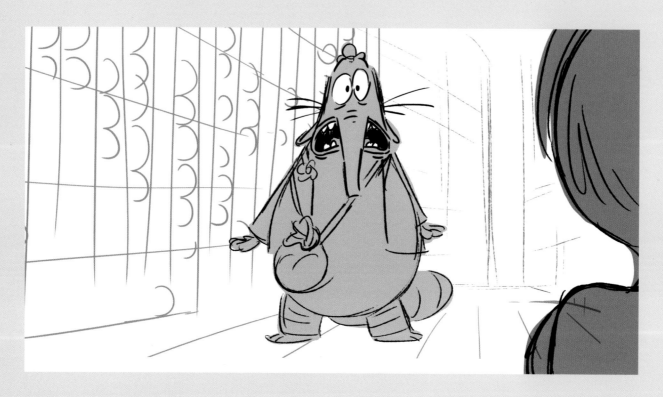

JOSH COOLEY Digital

TONY FUCILE Digital painting

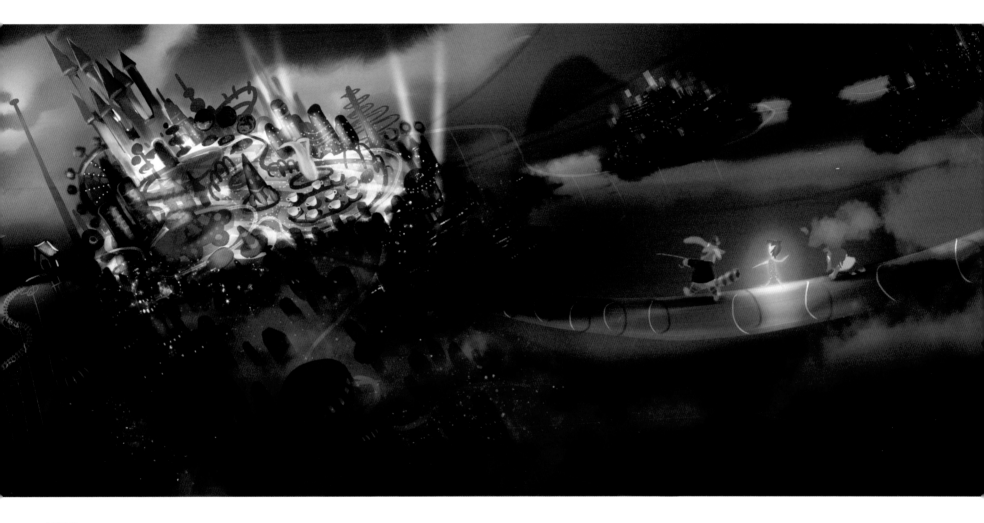

ABOVE
RALPH EGGLESTON Digital painting

OPPOSITE
CHRIS SASAKI Digital painting

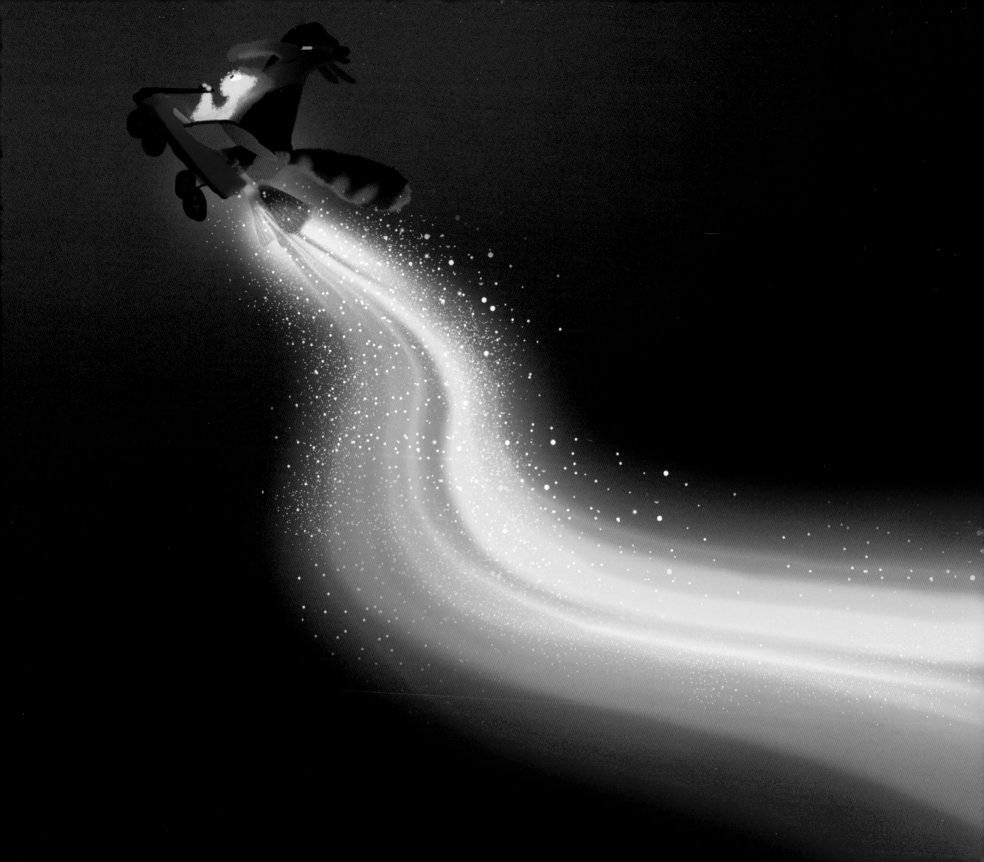

RALPH EGGLESTON Digital painting

RALPH EGGLESTON Digital painting

Joy and Sadness in the Idea Fields, where new
concepts are cultivated.

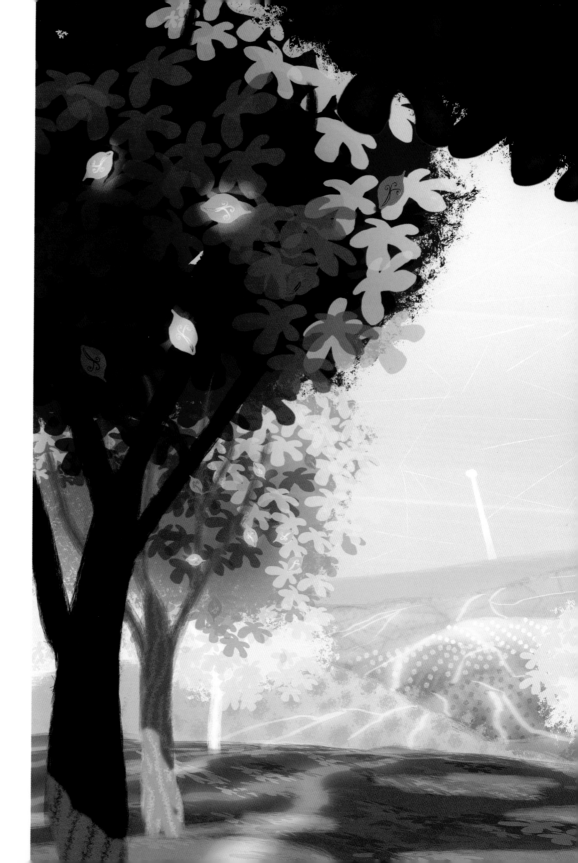

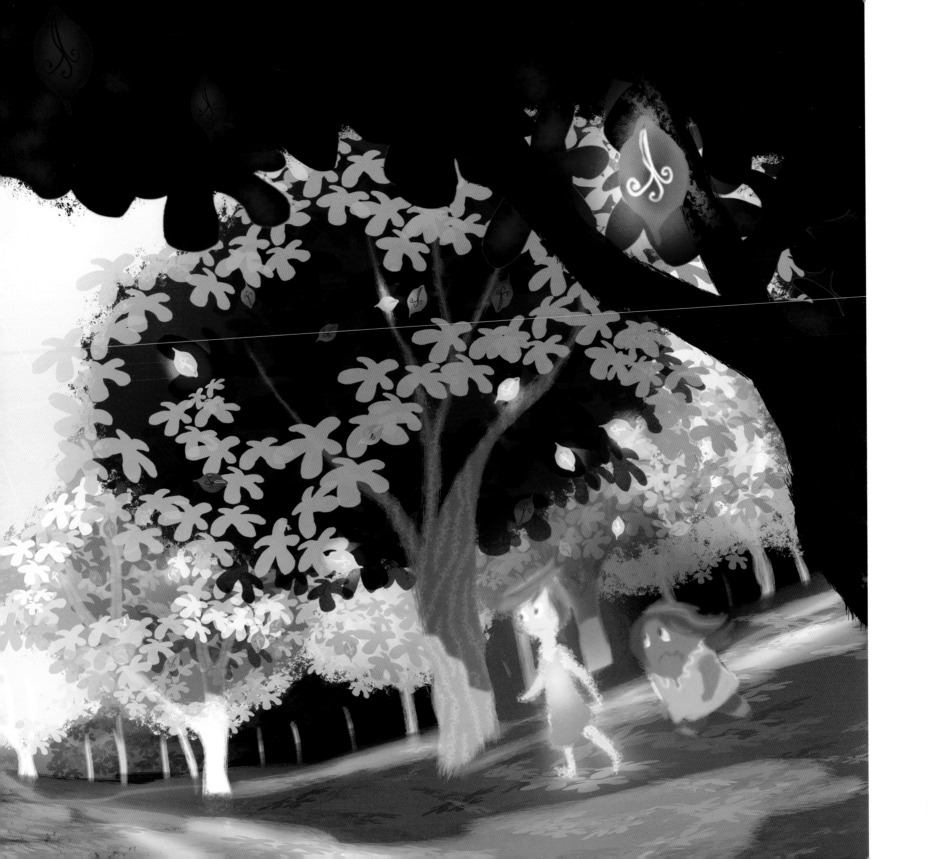

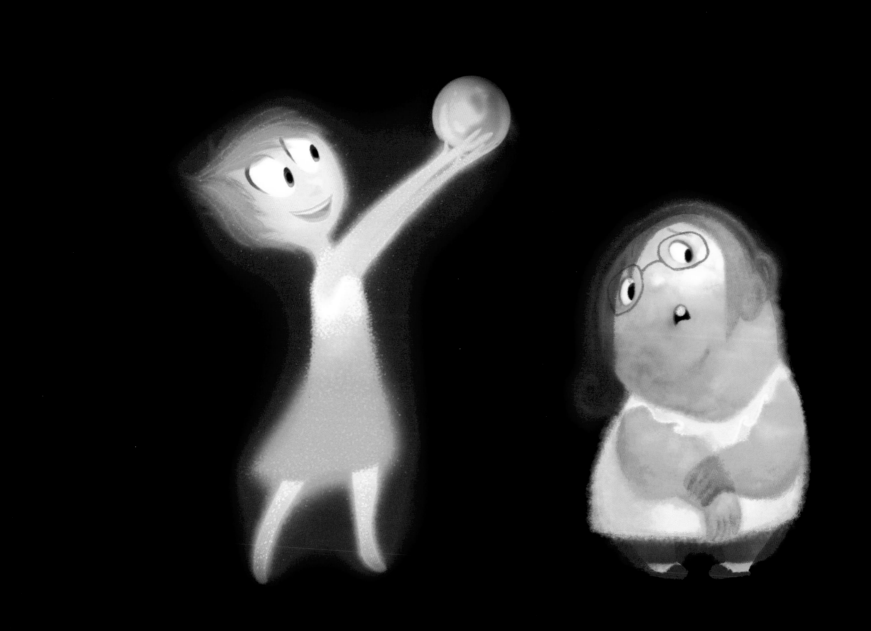

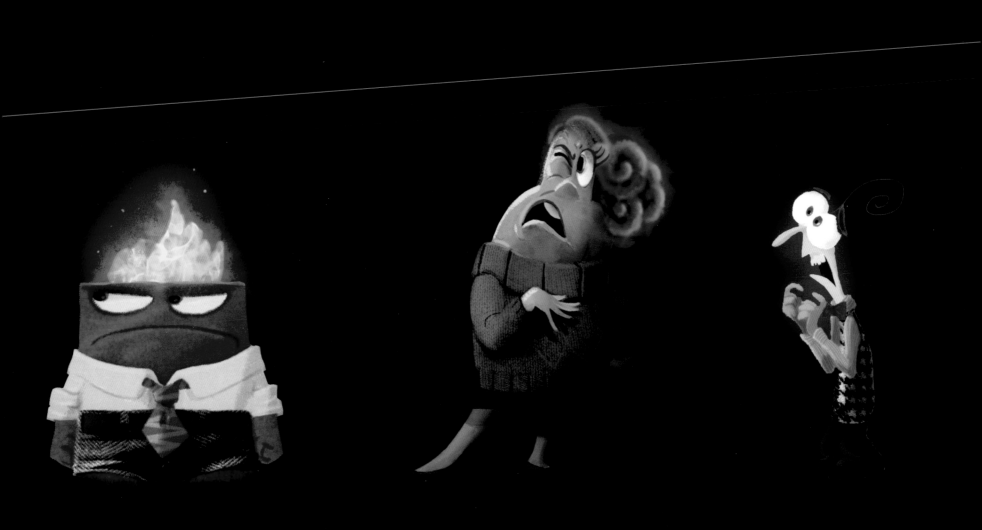

PREVIOUS SPREAD

ALBERT LOZANO Digital

THIS PAGE

SHAWN KRAUSE Ink

Animators often explore ideas for acting and
movement in thumbnail drawings.

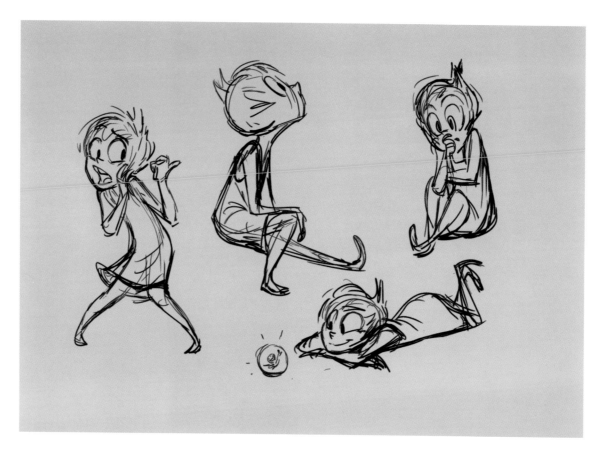

EVAN BONIFACIO Digital

LET'S NOT PANIC, PEOPLE!
RILEY STILL HAS THE MOST IMPORTANT THING:
US!
WE CAN RUN THE SHOW!
WE'RE HER PERSONALITY NOW.

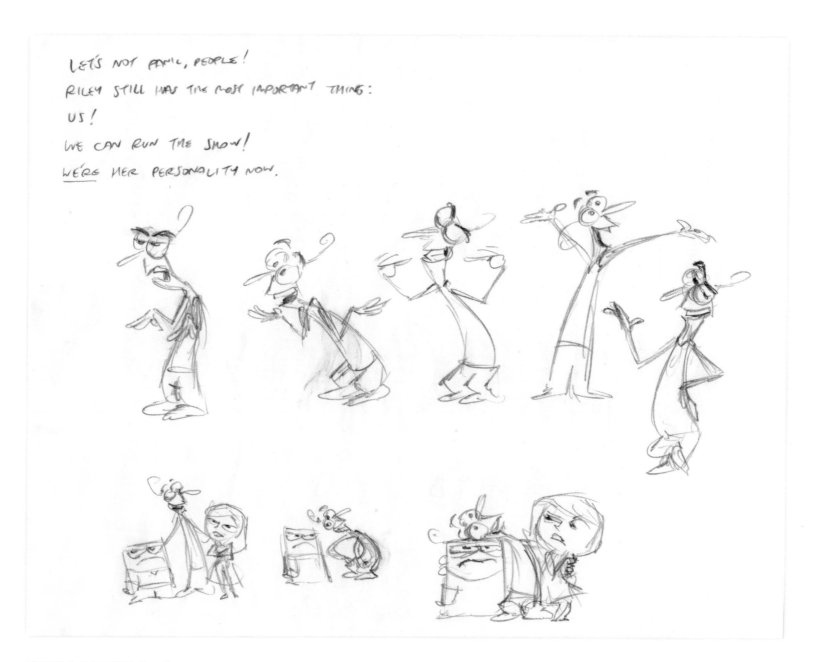

VICTOR NAVONE Pencil

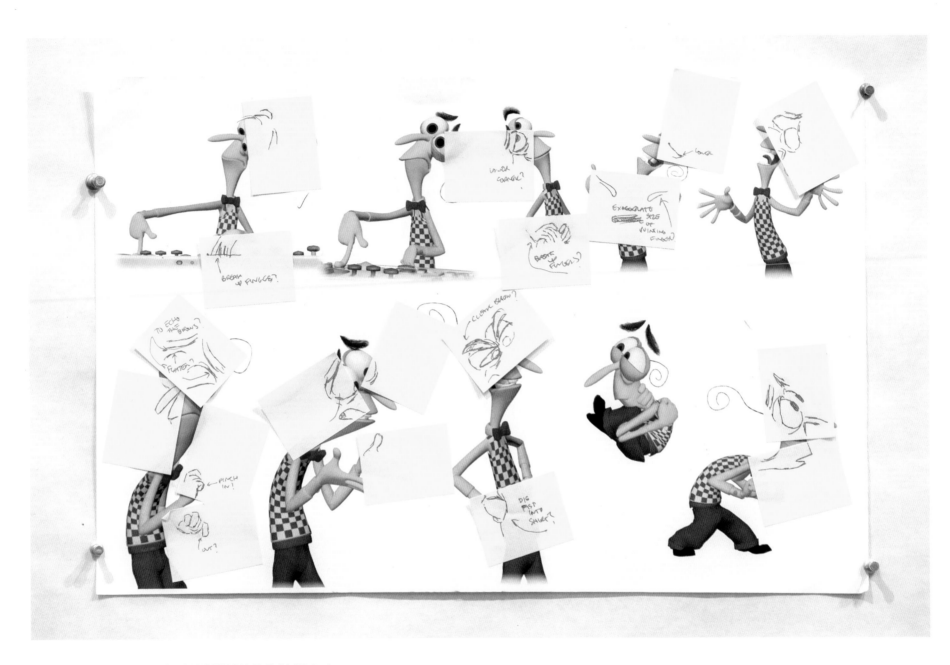

VICTOR NAVONE and TONY FUCILE (Ink) Digital poses

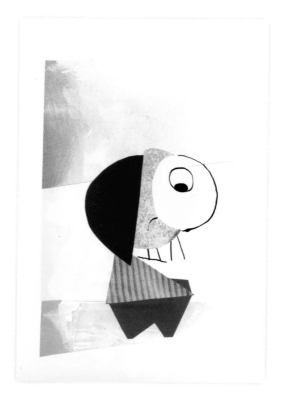

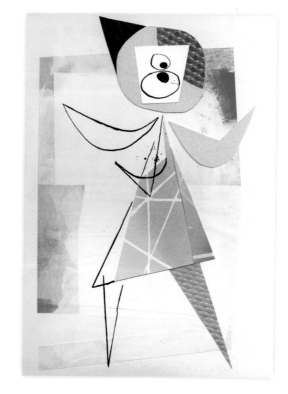

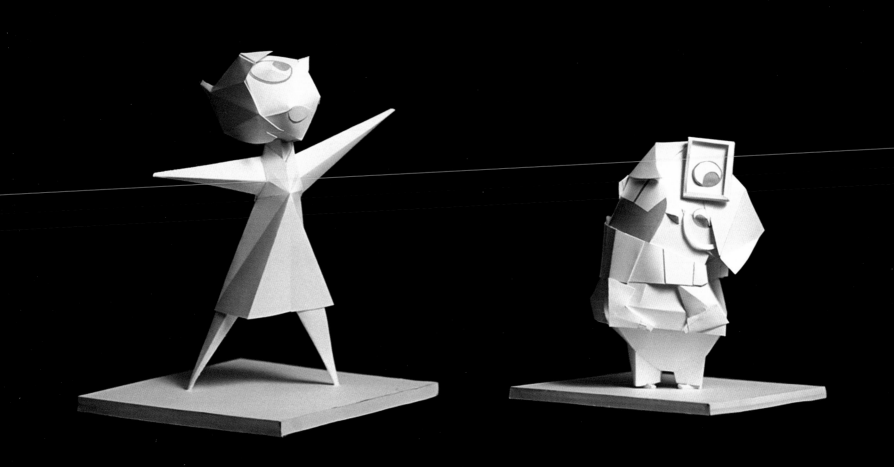

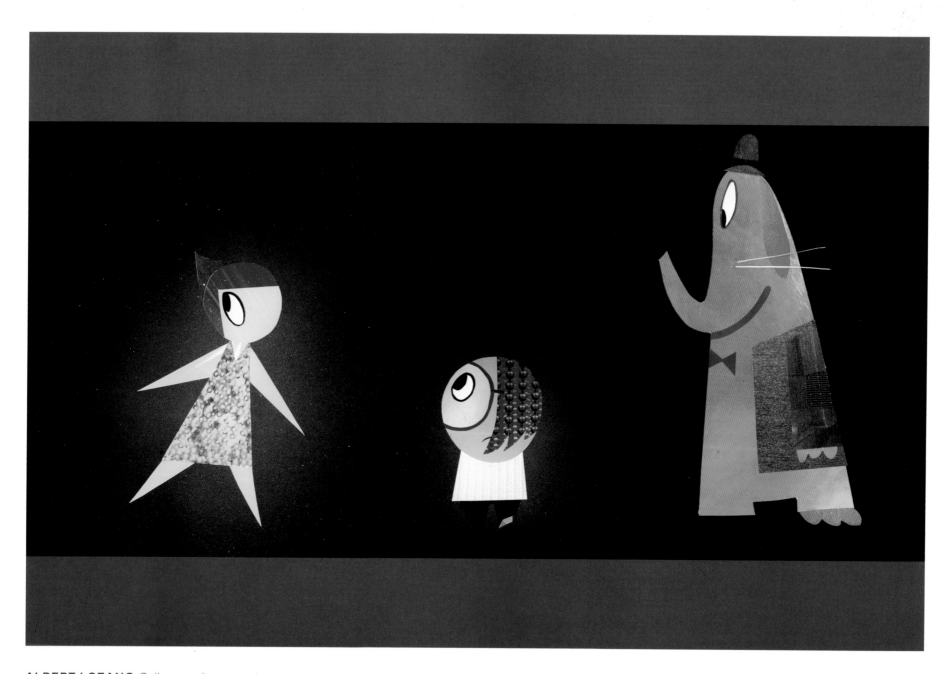

ALBERT LOZANO Collage and spray paint

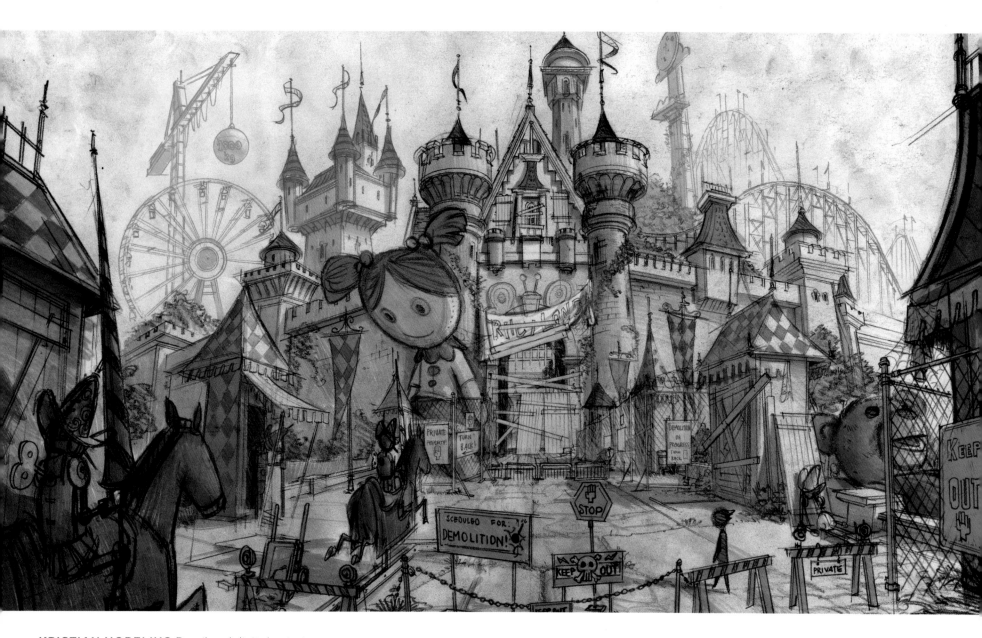

KRISTIAN NORELIUS Pencil and digital painting

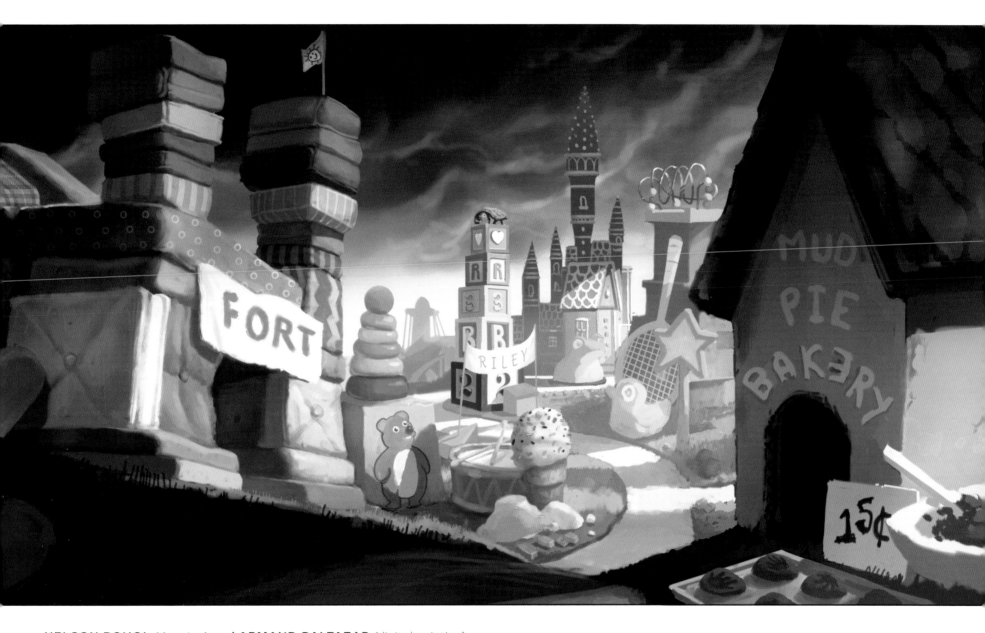

NELSON BOHOL (drawing) **and ARMAND BALTAZAR** (digital painting)

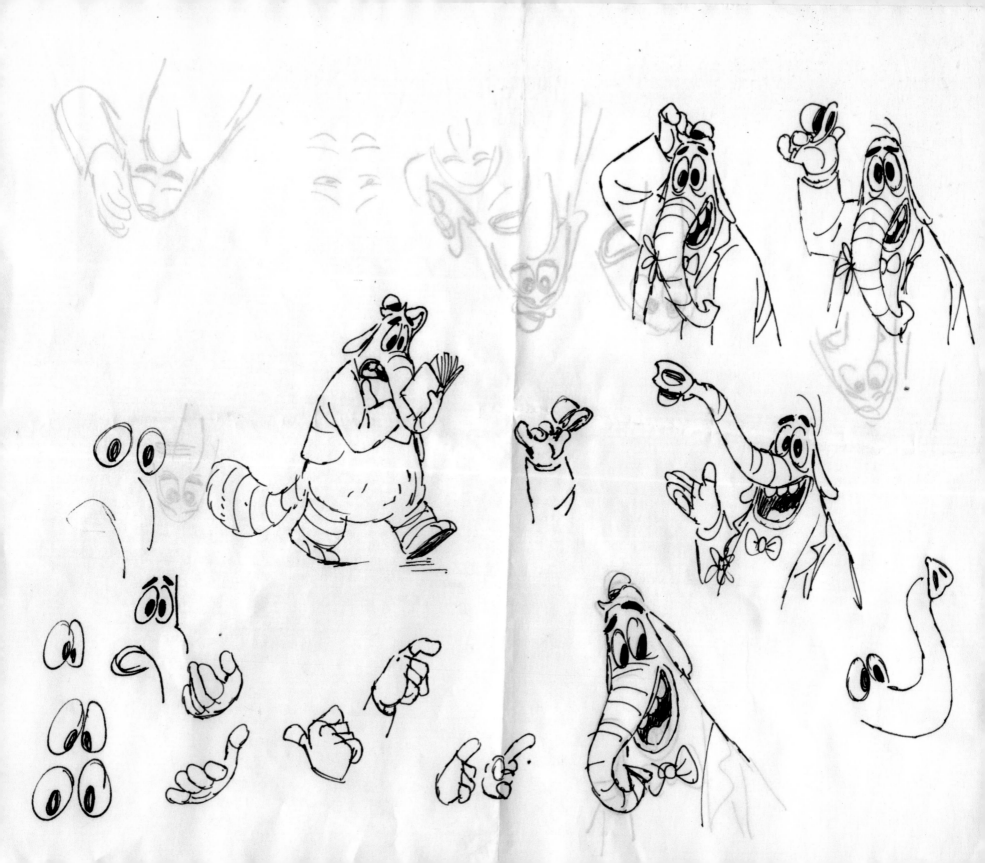

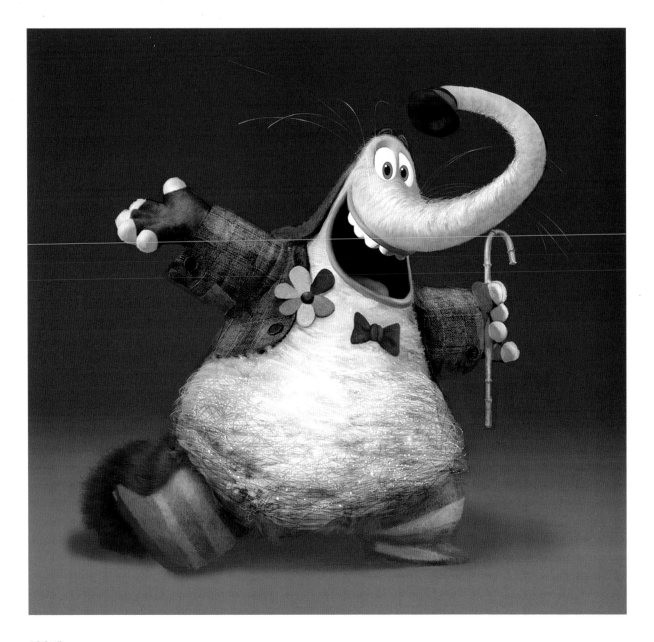

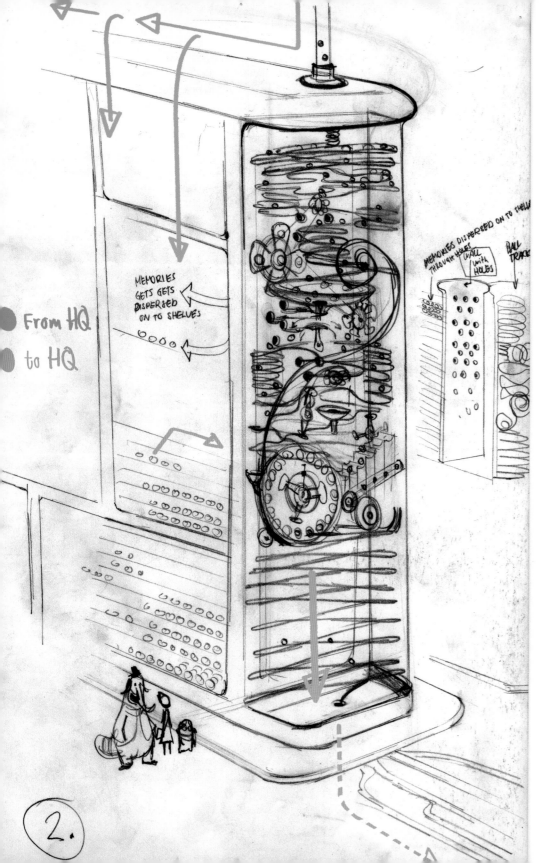

From HQ

to HQ

MEMORIES GETS GETS DISPERSED ON TO SHELVES

MEMORIES DISPERSED ON TO SHELVES
THROUGH HOLES

WALL WITH HOLES

BALL TRACK

2.

LEFT
KRISTIAN NORELIUS Marker and pencil

OPPOSITE
CHRIS SASAKI Digital painting

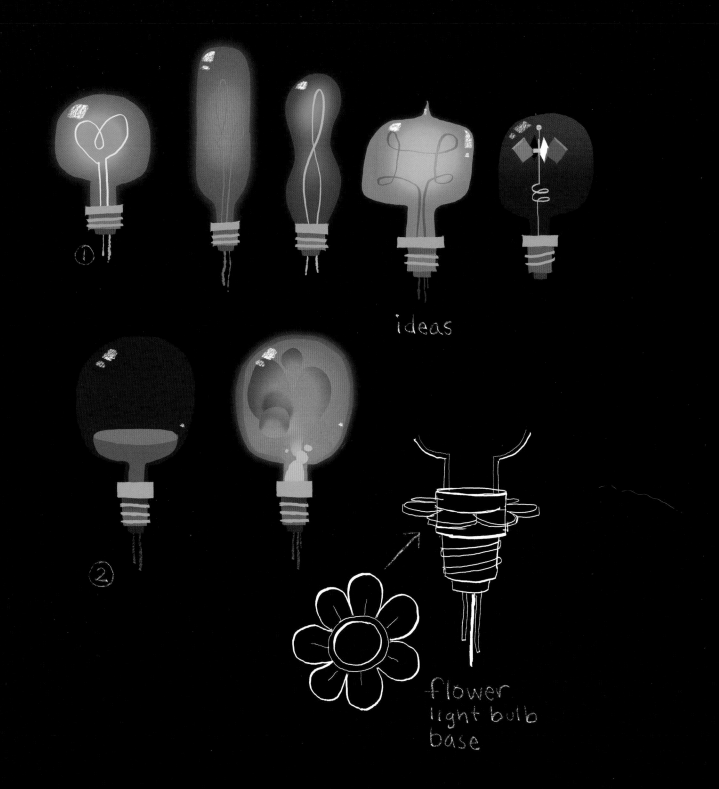

ideas

flower
light bulb
base

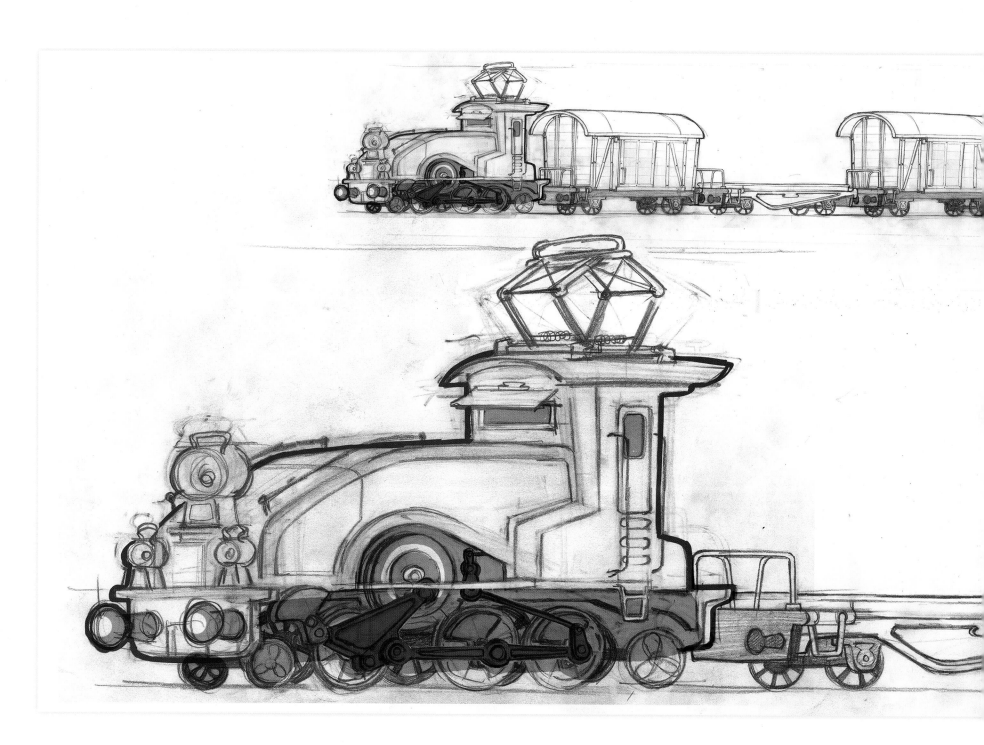

146

d480 - HOCKEY PATHS

GOALIE

RILEY

B

C

E

F

A D

J

I

H

G

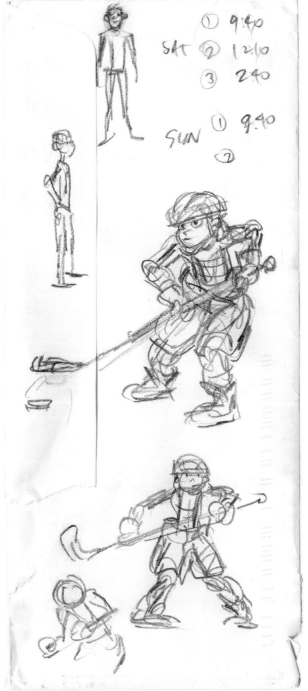

① 9:40

SAT ② 12:10

③ 2:40

SUN ① 9:40

②

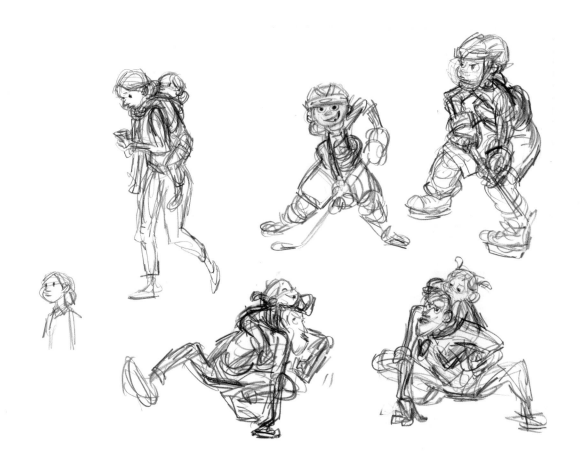

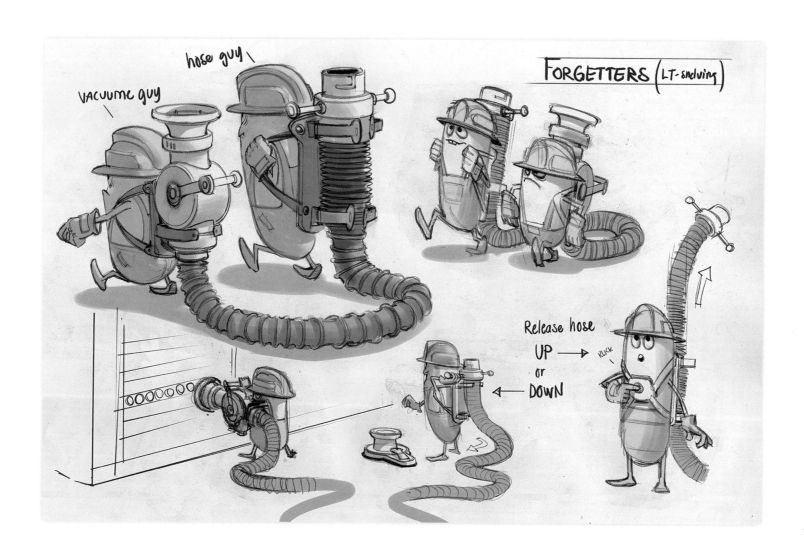

vacuume guy

hose guy

FORGETTERS (LT-shelving)

Release hose
UP →
or
DOWN

KLICK

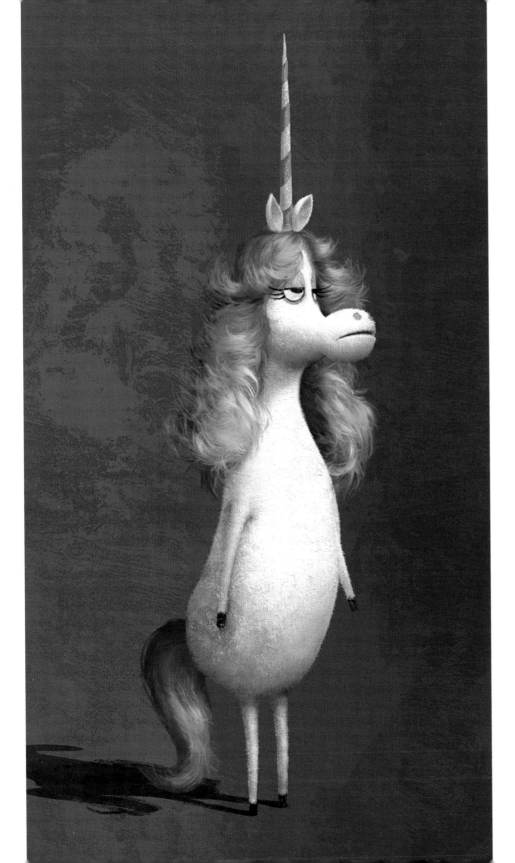

PREVIOUS SPREAD
CHRIS SASAKI Digital painting

THIS PAGE
SHELLY WAN, CHRIS SASAKI
Digital painting

OPPOSITE
KRISTIAN NORELIUS
Pencil and digital painting

STARRING
RILEY ANDERSEN IN DREAM PRODUCTION STUDIOS

I WOKE UP AND WAS A
PRINCESS
DREAM PRODUCTION STUDIOS PRESENTS "I WOKE UP AND WAS A PRINCESS" STARRING RILEY ANDERSEN
WRITTEN BY RILEY ANDERSEN PRODUCED BY RILEY ANDERSEN
GUEST STARRING THE UNICORN MUSIC COMPOSED BY DREAM PRODUCTION STUDIOS
ORIGINAL SCORE DREAM PRODUCTION STUDIOS

Riley Andersen in
I CAN FLY!
DREAM PRODUCTION STUDIOS PRESENTS "I CAN FLY!" STARRING RILEY ANDERSEN WRITTEN BY RILEY ANDERSEN
PRODUCED BY RILEY ANDERSEN MUSIC BY DREAM PRODUCTION STUDIOS

IN A WORLD
WHERE ANYTHING
IS POSSIBLE

RILEY
ANDERSEN
CAN BREATH
UNDERWATER
DREAM PRODUCTION STUDIOS PRESENTS "I CAN BREATH UNDERWATER" STARRING RILEY ANDERSEN
WRITTEN BY RILEY ANDERSEN PRODUCED BY RILEY ANDERSEN
GUEST STARRING THE WATER MUSIC COMPOSED BY DREAM PRODUCTION STUDIOS

CRAIG FOSTER Digital

FROM THE MIND OF RILEY ANDERSEN
DREAM STUDIOS PRODUCTIONS PRESENTS

SOMETHING'S CHASING ME!

DREAM PRODUCTION STUDIOS PRESENTS "SOMETHING'S CHASING ME" STARRING RILEY ANDERSEN
WRITTEN BY RILEY ANDERSEN PRODUCED BY RILEY ANDERSEN
GUEST STARRING SOMETHING MUSIC COMPOSED BY DREAM PRODUCTION STUDIOS
ORIGINAL SCORE DREAM PRODUCTION STUDIOS

I'M FALLING
FOR A VERY LONG TIME
INTO A PIT

DREAM PRODUCTION STUDIOS PRESENTS "I'M FALLING FOR A VERY LONG TIME INTO A PIT"
STARRING RILEY ANDERSEN WRITTEN BY RILEY ANDERSEN PRODUCED BY RILEY ANDERSEN
GUEST STARRING THE PIT

THEY WERE THERE WHEN I GOT TO SCHOOL

WHERE ARE MY PANTS?!

DREAM PRODUCTION STUDIOS PRESENTS "WHERE ARE MY PANTS?!" STARRING RILEY ANDERSEN
WRITTEN BY RILEY ANDERSEN PRODUCED BY RILEY ANDERSEN
GUEST STARRING RILEY'S PANTS

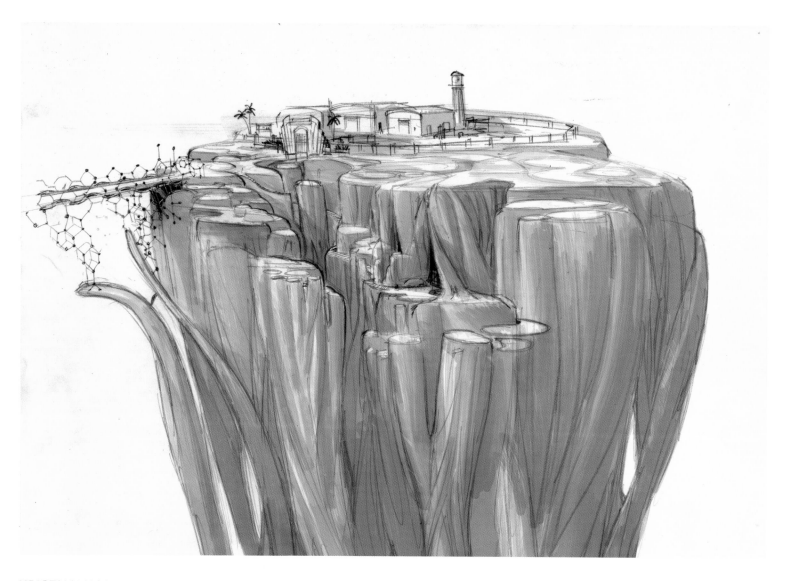

KRISTIAN NORELIUS Pencil and digital painting

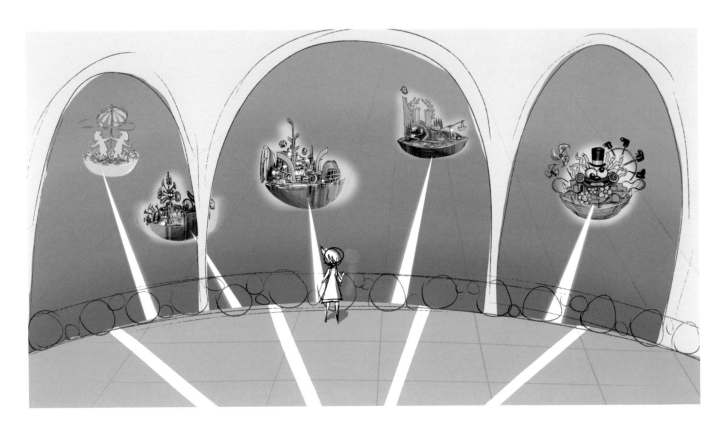

RONNIE DEL CARMEN Digital

157

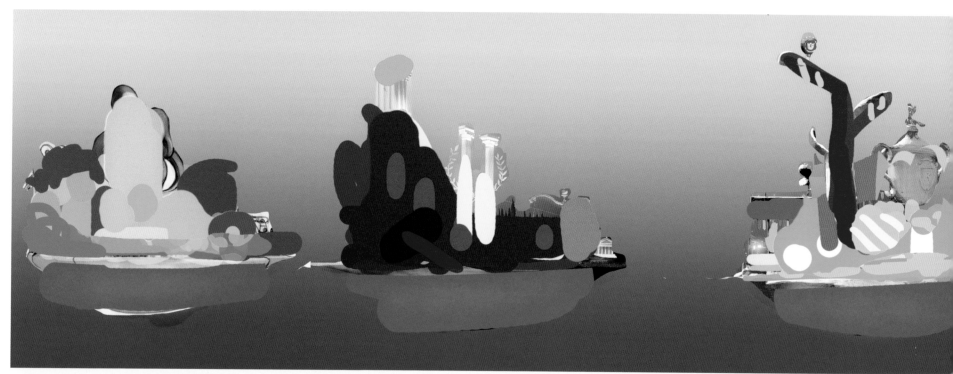

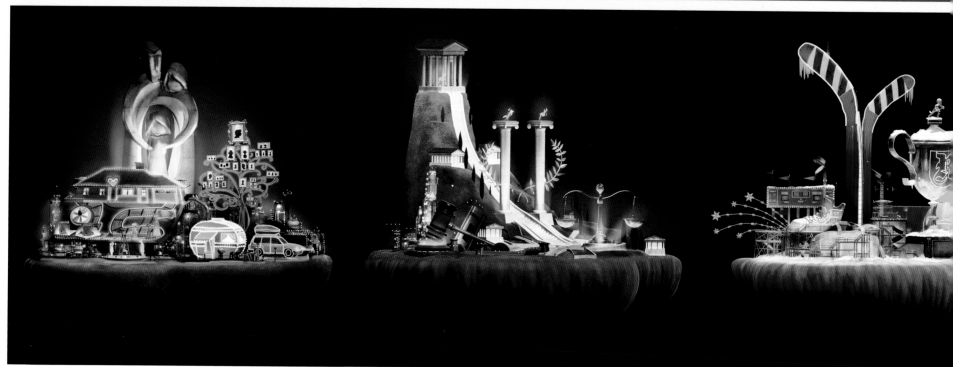

158

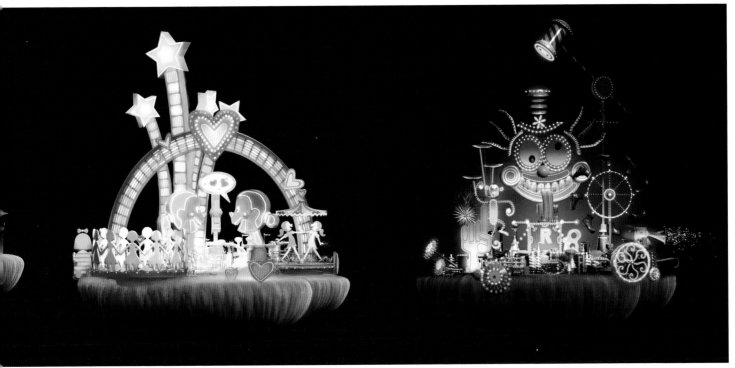

TOP
RALPH EGGLESTON
Digital painting

BOTTOM
ERNESTO NEMESIO
and PAUL TOPOLOS
Digital painting

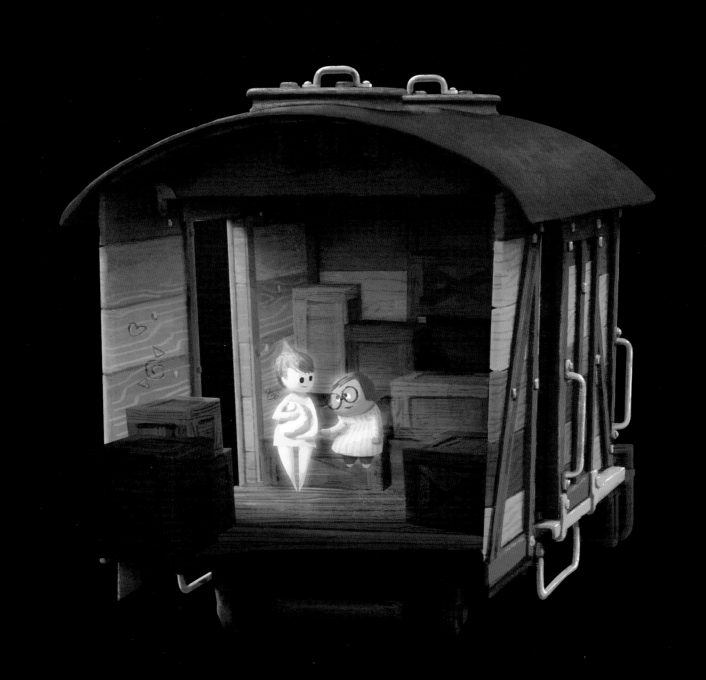

TOM GATELY Pencil

JOSH COOLEY Digital

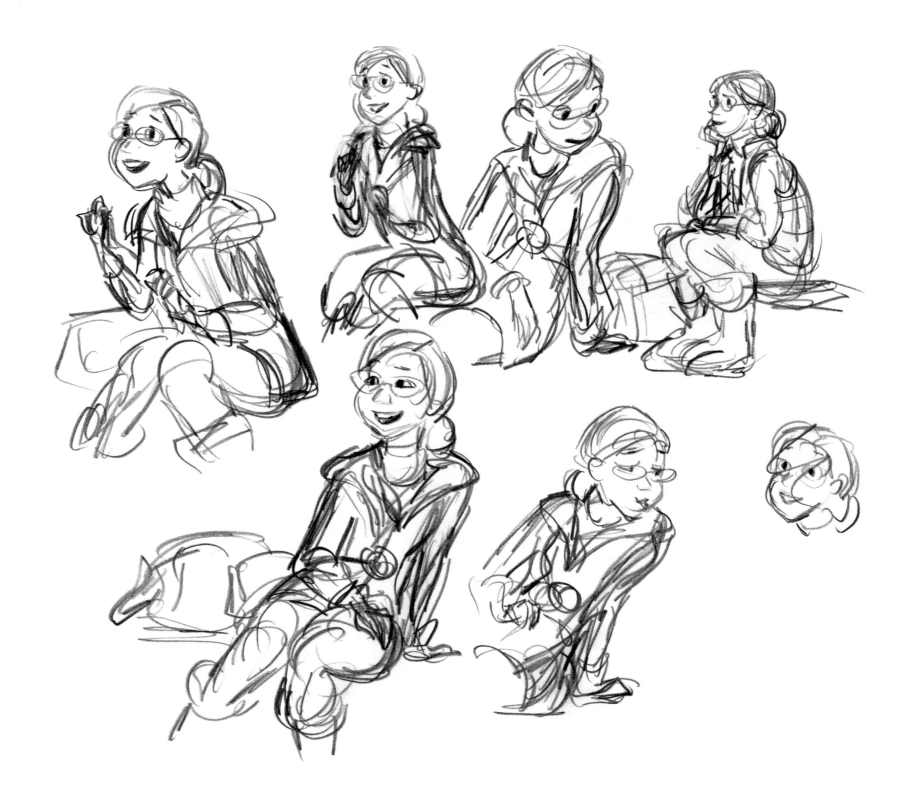

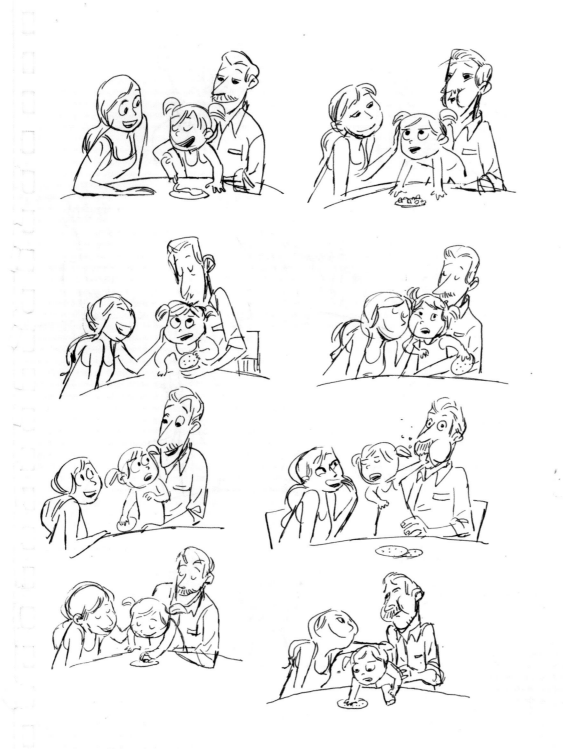

THIS PAGE
TERRY SONG Ink

OPPOSITE
TOM GATELY Pencil

BELOW AND RIGHT

TONY FUCILE Digital pose draw-over

Tony sat in dailies every morning, drawing over
animators' work. His sketches were a great help
in indicating how the poses and attitudes of our
computer models could be strengthened.

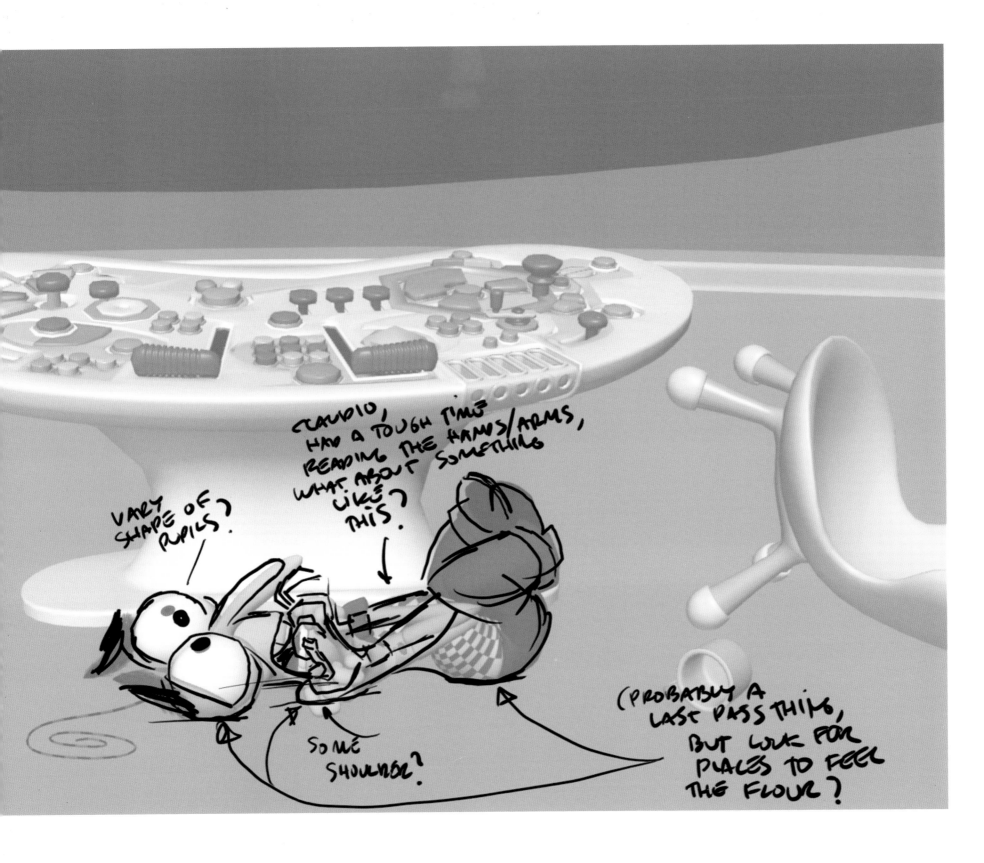

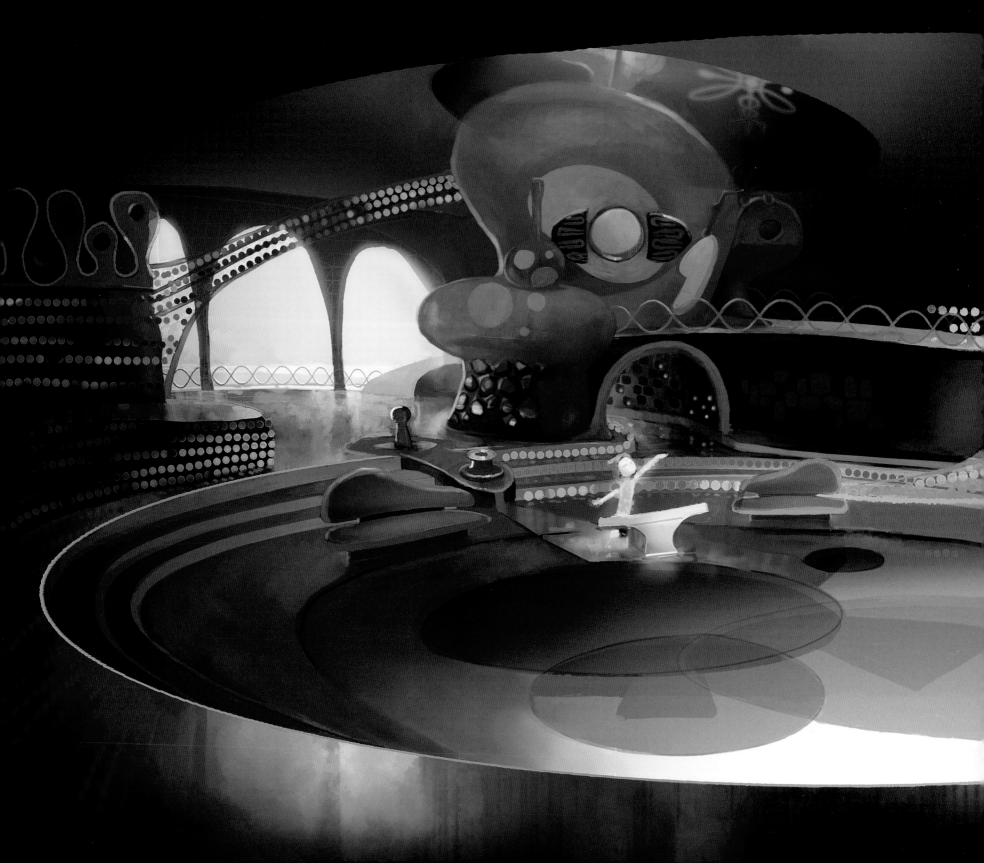

ARMAND BALTAZAR and PHILIP METSCHAN (digital layout)
Digital painting

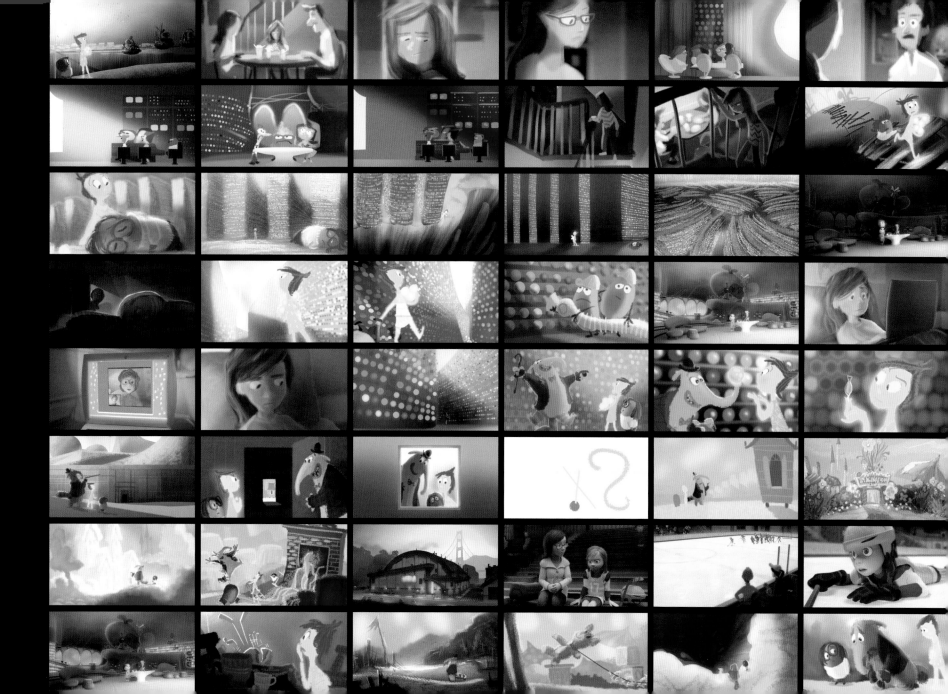

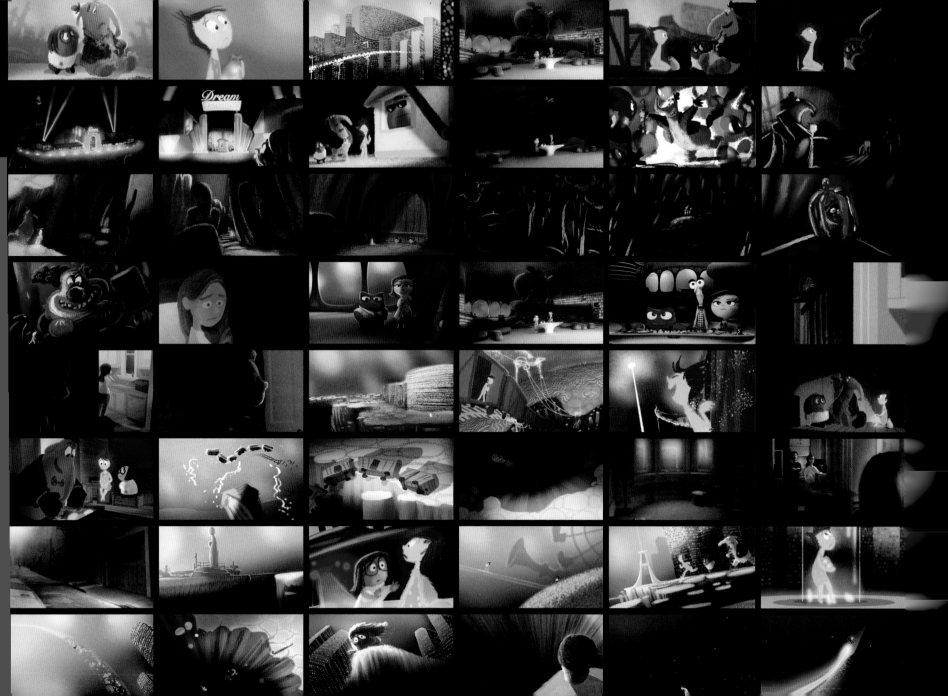

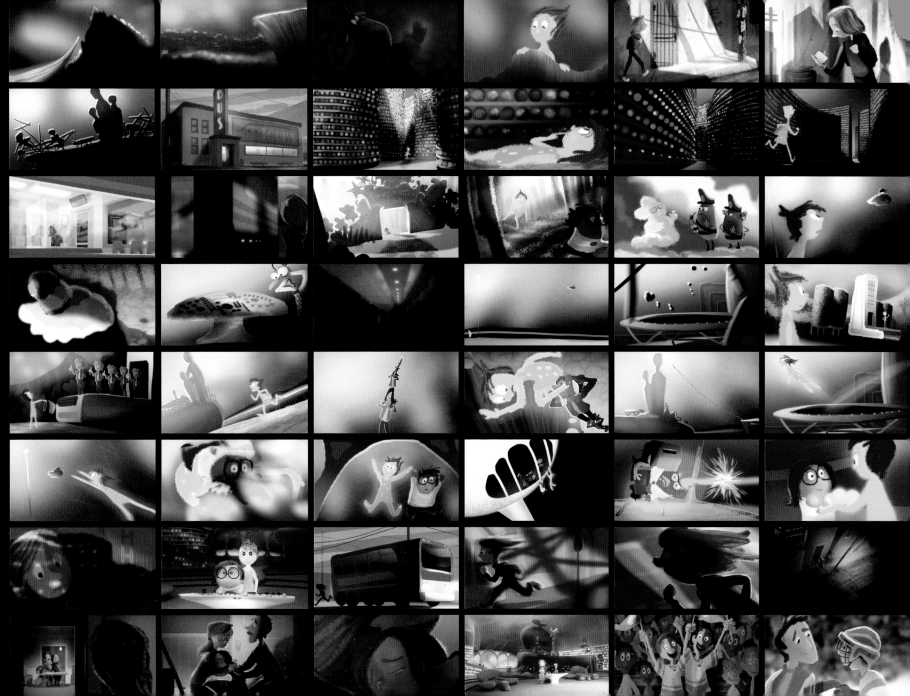

174

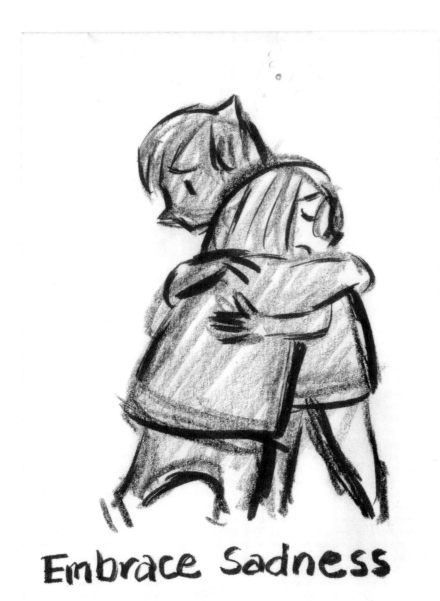

Embrace Sadness

THIS PAGE AND OPPOSITE
RONNIE DEL CARMEN
Pencil and marker

Acknowledgments

This book wouldn't be possible without the tireless work of the *Inside Out* Art and Story departments as well as the Pixar Publishing team: Erik Langley, May Iosotaluno and Pauline Chu (our Ninja Sharx), Samantha Wilson, Isabel Conde, Molly Jones, Kelly Bonbright, Lee Rase, Margo Zimmerman (#shenamedthemovie), and Jeanette Marker. Also, many thanks to our dear friends at Chronicle Books: Jessi Rymill, Emily Haynes, Neil Egan, Lia Brown, and Beth Steiner. A special shout-out to Sarah Malarkey who jumped on board with us way back on *Monsters, Inc.* when Michele Spane made the pitch that if we're going to make "Art of" books we should work with the best publisher on the planet.

Special thanks to Co-Director, Ronnie del Carmen, whose drawings showcased in this book, provided the first glimpse of how the movie might look and feel. There would not be a film without him.

Many thanks to Production Designer, Ralph Eggleston and Story Supervisor, Josh Cooley. They shaped the film with their art and led amazing teams that created awe-inspiring work, as you have seen on these pages.

To the *Inside Out* Production team: Mark Nielsen, Dana Murray, Michael Fong, Elissa Knight, and Victoria Manley. May this be one of many "Art of" books that we share together.

And to the Pixar Executive Team that supported us along the way: John Lasseter, Ed Catmull, Jim Morris, Tom Porter, Marc Greenberg, Jim Kennedy, Lori McAdams, and Steve May.

We draw inspiration from many sources and therefore we'd like to thank the following fine folks and organizations: Jonathan Garson, Howard Green, Amy Poehler, Bill Hader, *Saturday Night Live,* David Schaeffer (for the chill chamber), Mexicali Rose, Merritt Bakery, Teacake Bake Shop, the Oakland Raiders, the Oakland Athletics, the Oaks Card Club, Disneyland, Chateau Marmont, *The Muppet Show,* and The Walt Disney Family Museum for letting us use their amazing building when we were first putting this movie together.

Most important, thanks to all the Pixar employees who made this film. We suspect you'll never know how much we appreciate the work you do.

JONAS RIVERA
Producer, *Inside Out*

PETE DOCTER Marker